GEORGE SOPER'S
HORSES

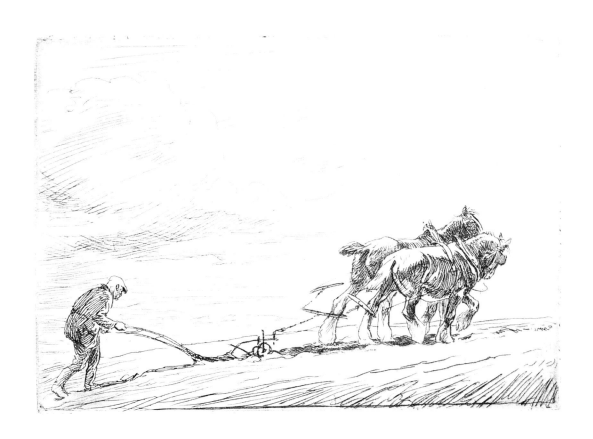

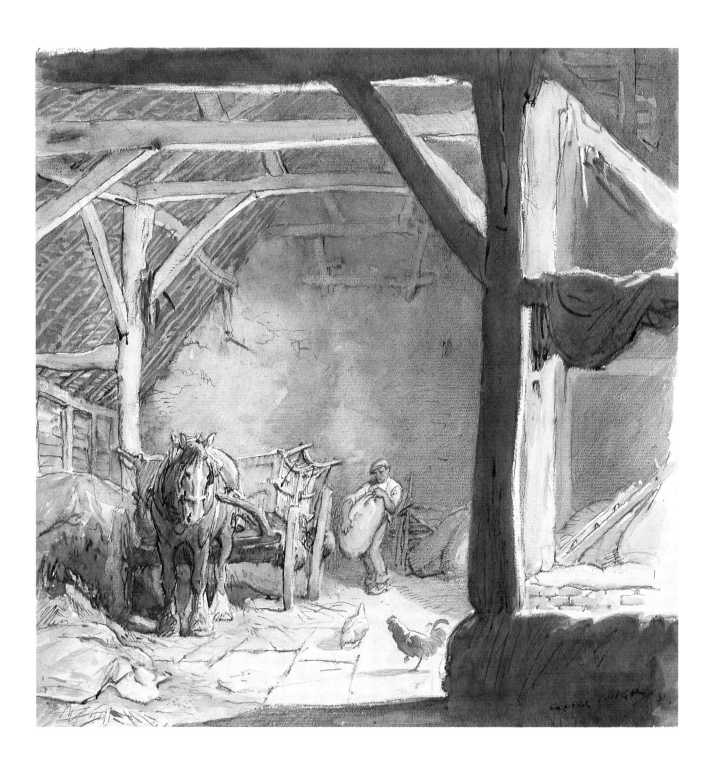

PAUL HEINEY

GEORGE SOPER'S HORSES

Illustrations by
GEORGE SOPER R. E.

Houghton Mifflin Company

Boston 1991

For information about permission to reproduce selections
from this book, write to Permissions, Houghton Mifflin
Company, 2 Park Street, Boston, Massachusetts 02108.

First published in Great Britain in 1990 by H. F. & G. Witherby Ltd
14 Henrietta Street, London WC2E 8QJ

CIP data is available.
ISBN 0-395-58040-4

10 9 8 7 6 5 4 3 2 1

Designed by Cornelia Playle
Set in Monotype (hot metal) Bembo (270) by
Gloucester Typesetting Services, Stonehouse, Glos.
Printed and bound in Great Britain by
Butler & Tanner Ltd, Frome, Somerset

CONTENTS

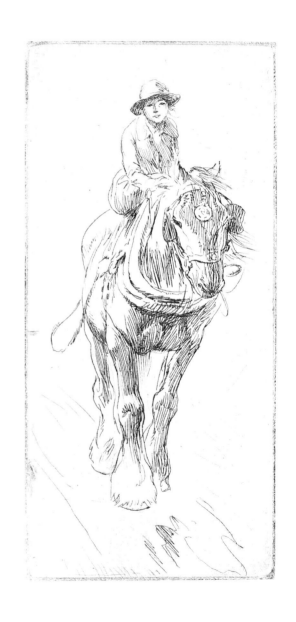

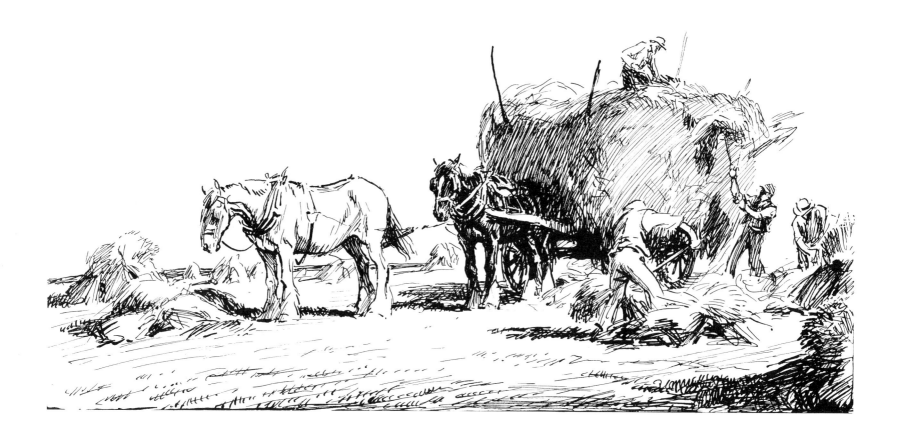

INTRODUCTION

THIS BOOK IS a tribute both to George Soper the artist, and to the farming horses that he loved so dearly. He was fortunate to live and work in the first half of this century, when it could be truly said that the cart-horses of England were enjoying their golden age. Although under threat from the ever more efficient tractor during the 1930s and '40s, they loyally ploughed and sowed, reaped and mowed the fields of England till the internal combustion engine finally claimed its greasy, noisy victory. The end of the golden age in the '40s was also the end of George Soper's life. He died in 1942.

The drawing of working horses was not his living, but rather his personal passion: and the remarkable paintings, drawings and etchings in this book might have gone undiscovered were it not for a fortunate intervention, which it is well worth a diversion to describe.

The Soper family home was in the outer suburbs of North London, near Welwyn Garden City. The house itself was set in four acres and George Soper, way ahead of his time, had decided as long ago as the 1920s that the garden should be a wildlife habitat. After he died, his conservation work was carried on by his two daughters Eileen and Eva, neither of whom married, and who continued to live together in the house. Eva was a skilled potter who produced some fine commercial work and Eileen, like her father, was an artist. At one time she was principal illustrator for Enid Blyton. She died in 1990 during the preparation of this book.

But like her father, Eileen had a secret passion for the wildlife that came to visit her four-acre wilderness in what was becoming an ever more populated part of outer London. Over a period of eight years she succeeded in attracting a colony of muntjac deer and wrote and illustrated a book telling of the patience required to win the confidence of these tiny, timid animals. In the preface to her book she wrote:

> "The garden was created on the slope of a meadow overlooking a wide landscape of field and woodland, open to the south wind, to sunlight and changing skies. Shaped to the artist's vision, it lost little of the wild element, and the meadow was never entirely tamed. But in time, growing trees and shrubs changed its character: birds of the fields, which had nested there in the garden's early days, began to seek more open land, and to be replaced by those of woodland and hedgerow . . . My father did not live to see the coming of the muntjac, and when he died my sister and I took over responsibility of the garden and sanctuary. Our affections for plant and animal life were shared, but it was natural that my sister, who had inherited father's skill in the garden, should find her chief interest in the plants, while mine was more definitely centred on the wildlife."

As well as the muntjac deer, Eileen Soper developed a passion for, and a deep understanding of, badgers; and wrote several books which she illustrated.

Having lived all their lives in the old family house, it was understandable that as they grew older they would not wish to leave it. But with the Soper sisters now in their eighties, the maintenance of the garden was far beyond them. They did not have many visitors, and might have been thought of as recluses; the truth is that they simply preferred the company of each other and the wild animals to that of other people. Alone, surrounded by ever thickening wilderness, the Sopers fed young badgers by hand, and encouraged wild birds to feed in the house.

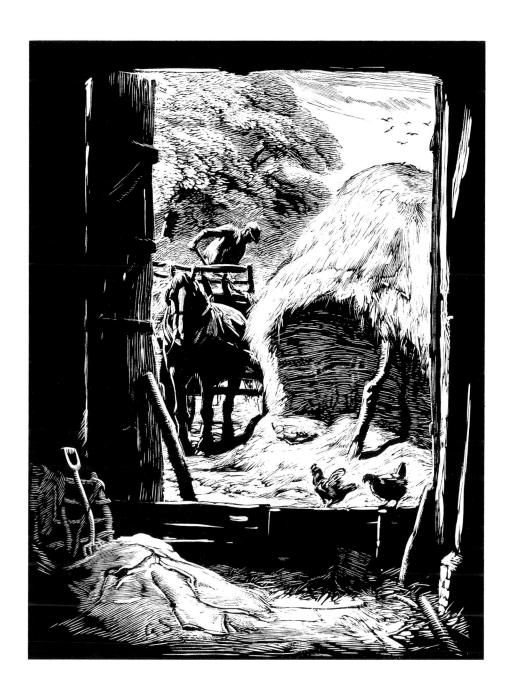

One friend who was trusted was Robert Gillmor, a distinguished bird-artist and President of the Society of Wildlife Artists. When, a couple of years ago, Eileen fell ill and with her sister entered a nursing home, Gillmor was invited to the house to help sort out the artwork.

What met him was a remarkable scene, best described in his own words:

> "Oh boy! I was faced with a house full of bundles of pictures. They were everywhere. There was a glorious studio which was piled high with work and in the kiln-room where Eva did her pottery were boxes of mouldering books and old 18th-century ledgers which had been bought for the quality of the handmade paper. I opened a drawer and it was just full of prints and huge parcels that had been returned from publishers and left unopened. I knew Eileen's work well and that her father was an artist – but of his work I knew nothing. I had no idea what I would unearth."

In fact, Gillmor unearthed the largest-ever collection of drawings and paintings of horses at work. There were 177 watercolours, 71 wash and pencil drawings, 195 landscapes and 53 unfinished works. In addition there were 2,500 prints and 57 sketchbooks, hardly any of which had ever been seen before. Treasure trove. The best of them are the heart of, and reason for, this book.

A word of explanation is also needed as to why I am writing the text that accompanies – and, I hope, enlightens – this collection of George Soper's work. Like him, I too have a love of the working horse. But whereas he was able to find satisfaction in sitting in the corners of fields or on haystacks and drawing, I have found my pleasure in taking hold of the handles of the plough, calling to the horses and walking the furrow.

It happened by chance, when I met a pair of young people who farmed with horses in Suffolk not far from where I live. They were not running a museum, nor were they insane; they simply believed in the sheer

usefulness of the farm-horse and decided that on their farm they would make best use of them. Roger and Cheryl Clark keep a stable of about half-a-dozen Suffolk Punches and it was on their farm, three years ago, that I worked one day a week for a year as a farm-hand, and wrote a book about it.

It turned out to be a formative experience. Having had a taste of life on the land and the ways of the working horse, I found it impossible to turn my back on it and simply mark it all down to experience. Consequently, I bought Suffolk Punches of my own and now work our small farm with them.

When I look at George Soper's work, I recognize in it a truth that is not there in the many chocolate-boxy depictions of farming scenes. He has an honesty which demands that he shows the strain of often gruelling farm-work, not only on the horses but on the men: he is not afraid to show us that not all furrows were as straight as some of the old-timers and the adherents of ploughing-matches would have us believe. We can clearly see the strain on the horses used for hauling timber, a strain which often killed them at an early age. His work faithfully portrays the working horse as not only a powerful tool, but as an obedient friend and companion of the men who worked him. In this book I have tried to provide a background to Soper's honest pictures by explaining the reality of the trade he portrayed: how the cart-horse developed and how they were used on farms. But no words that I could write can convey the spirit of the time, the brief golden age of the English farm-horse, as vividly as George Soper's paintings.

——— 1 ———

GEORGE SOPER

OF GEORGE SOPER's life we know remarkably little. He was born in 1870 and exhibited at the Royal Academy every year from the age of 19 till he died in 1942.

He was no townsman. His heart and his life were in the country and when free from the pressures of earning a living he would flee to the fields and sit quietly on the headlands, drawing, as men and horses worked. But when he was forced to work in the commercial world he was able to do so in styles which would never suggest that this was an artist who could capture so vividly and affectionately horses at plough.

His commercial work included powerful posters, and he was an able illustrator of melodramatic tales which he complemented with swash-buckling drawings of *Boys' Own* heroes. It was a talent that gave him a good living. Born in Devon and brought up in Somerset with no artists in the immediate family, he was self-taught; only for a brief time did he study engraving under Sir Frank Short at the South Kensington School of Art.

The move to Hertfordshire with his two children, Eva and Eileen, was a formative one. For although Welwyn Garden City seems an unlikely place, these days, in which to find rural inspiration, when Soper moved there in the early years of the century, it must have felt like the very heart of the countryside. He became great friends with the local farmers and would slip away into the corners of neighbouring farms whenever his commercial work allowed him some freedom.

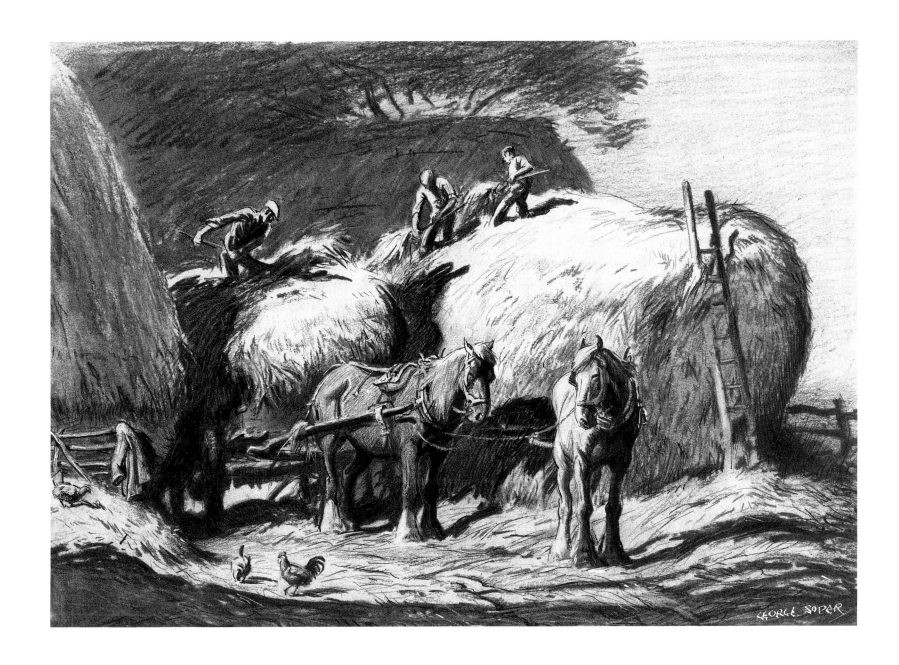

Meanwhile, at home, he continued on the construction of his wildlife garden and became a keen plantsman. He travelled to Switzerland and illustrated a botanical book by the famous plant-hunter Farrer; he took the opportunity to bring home to Britain rare species to plant in his developing Hertfordshire garden.

During the First World War, he offered himself to the army but was found to have a weak heart. He took a job as a war artist, sometimes would work until the early hours on subjects that were wanted in a hurry, travelling to London early the next day.

If this seems a rather sketchy portrait of a man, then that is how it must remain. Soper clearly preferred the solitude of the downlands and the open fields to any lively cosmopolitan scene that might have tempted him and in which he might have made his name. His friends were the ploughmen and farmers whom he drew, and none remain to tell the tale of the reserved, well-dressed figure with the sketchbook always in his hand. But his daughter Eileen wrote, much later:

> "The ploughman and his team were not, for him, merely an inspiring but impersonal subject. He walked with the man behind the plough, an interested and sympathetic listener. He was out on the harvest field, in the lane with the timber team, or with the men at 'beaver' (meal-break) seeking under the hedge some shelter from the biting wind."

It was Eileen who, 20 years ago, first planned to put together a book of her father's work with some of her personal reminiscence. It was never published, but a few notes in manuscript survive and give the best picture of her father that we can hope for:

> "I never drive round the corner of the steep lane near Aston without recalling a day in early March when my father and I took this road before mechanisation had entirely taken over field and farm.

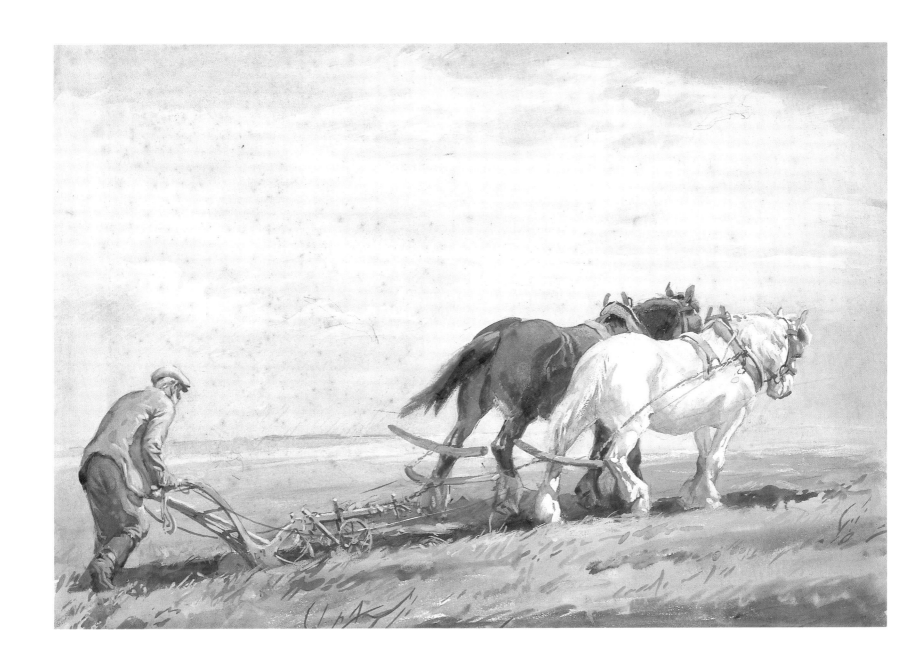

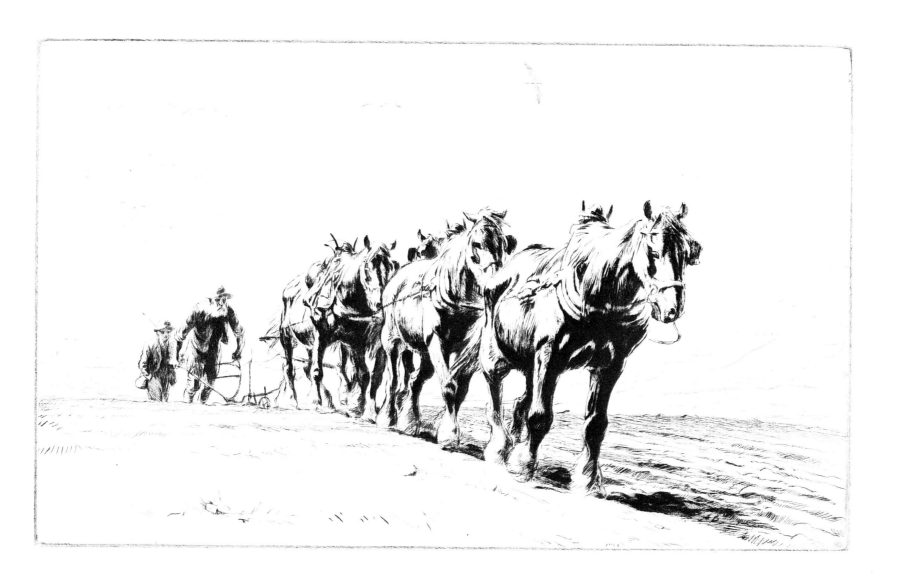

Winter had passed almost overnight and the clear atmosphere had suddenly brought to life the hidden colour – the scents and sounds that define the first moments of spring with its strange mingling of joy and sadness that is never more than half explained. Across the sunlit sky clouds were flying before a fresh wind that lifted the wings of the crying plover and gull, and on the wide expanse of field a man was ploughing, driving his team, splendid in colour and movement, seeming then as durable as the land and its purpose, a sight inspiring to the artist's eye.

"We stood on the high bank watching the horses as they passed rhythmically to and fro over the hill to the skyline, and down the long slope of the furrow to turn at the headland beside us. My father was sketching – he was never without his sketchbook on such occasions – as he worked, the spontaneous flowing lines of his pencil captured the life and movement of his subject with a freshness and vigour that reference to his work, whether in pencil, colour or engraving, brings intimate recollection of innumerable incidents and scenes depicting the life of the countryside, so much of which I shared with him, and which will never again be seen in Britain."

It was Soper's rural work that first drew critical attention, and when he was able to devote even more of his time to it his etchings were warmly welcomed. In a 1921 edition of *The Book Man's Journal and Print Collector*, Malcolm C. Salaman wrote:

"When Mr Soper laid aside the pen and ink of the book-illustrator, long plied with credit, and took up the etcher's needle and dry point, the change was more than one of medium; it involved an essential difference in the relation of the artist to his pictorial subject-matter; it meant artistic emancipation. No longer compelled at the dictate of the writer's narrative or description to compose a picture that should conform to a literary prescription, Mr Soper found himself free to

express in the etcher's idiom any artistic impulse stirred by the experience of his own personal vision. And to this happy liberty of choice all the artist in him naturally and promptly responded. Rid of the fetters of the commissioned illustration, he began to enjoy his artistic freedom in the meadows of the English shires, ranging at will, copper-plate or sketchbook in hand, among the sowers and reapers, the horses and cattle, and he may have felt much as Charles Lamb's Superannuated Man did in the experience of his unaccustomed liberty: 'I am now as if I had never been other than my own master. It is natural to me to go where I please, to do what I please.' For Mr Soper however, to find himself, like Elia, sauntering in Bond Street at eleven o'clock in the morning, or digressing into Soho to explore a book-stall, would have offered no delight. But to meet a team of horses hauling a timber-waggon in a Devon lane, to range among the shepherds on the Sussex downs, to see a hay-cart bringing the last load from a Hertfordshire meadow, and to enjoy the freedom to draw these things as he felt them on his copper-plates, this was the emancipation that made man and artist one happy entity."

After his death, his great collection of works was packed away in a seemingly random manner in the house, although even in her eighties Eileen could remember where every work had been put. There were occasional bursts of outside interest in his work and Eileen herself wrote a piece for *Country Life* in 1967, summing up her father's work:

"The value of sketching from life was always emphasised by my father, and he was out on the fields with his sketchbook on every possible occasion. In this way he also gained an intimacy with the land that brings to his work a sense of reality combined with the freshness, light and air of the countryside . . . He shared the dust of the threshing machine and the bitterness of the winter, following the mangold cart beside the cattle in the snow – always with sketchbook

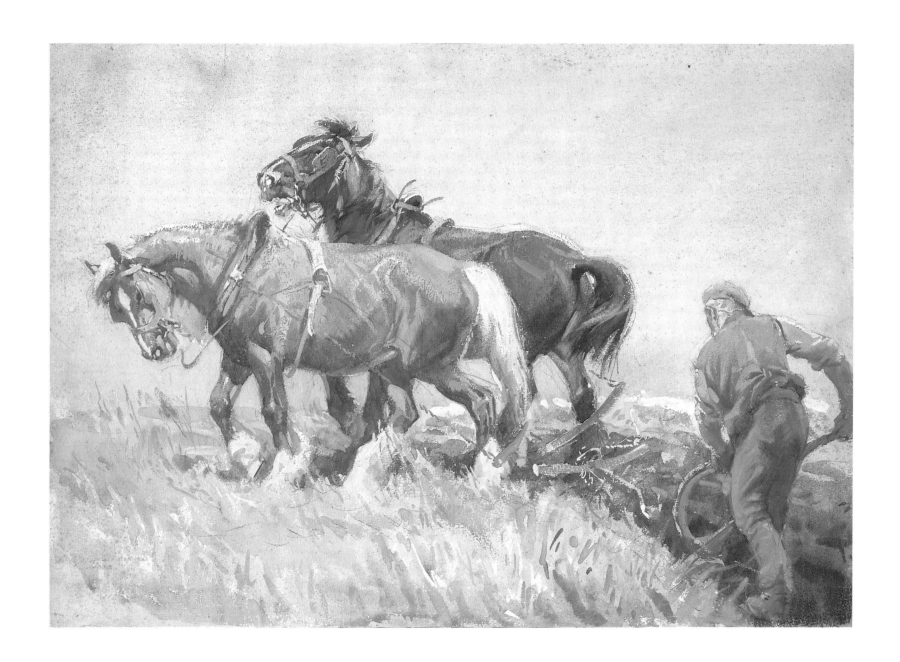

in hand. Summer objects too, had their fascination: shadows on the barn wall; a white pony resting in dappled sunlight; horses drinking by the bridge; milking in the open; a shepherd on the Sussex downs – all typical of the many scenes he recorded, perhaps without realising how soon they were to disappear from the land."

2

THE HORSES

THE SIGHT OF a team of steaming, glistening horses willingly hauling plough or harrow across the rolling English countryside, and by their efforts transforming the colour and texture of the land itself, is a moving sight. You don't have to be old enough to remember having seen it as a child to be stirred by it. It is an image of power and obedience; a perfect mix of man, horse and landscape.

This image of the working horse has an eternity about it which makes it easy to believe that it was centuries old. But the fact is that the era during which the cart-horse was king lasted little over 150 years. The golden days of the working farm-horse were brief, though glorious. It was not until the mid-19th century that ploughs and other gears were engineered to be sufficiently light for horses to pull efficiently; ironically, it was that same mechanical skill which led on to the development of the tractor and the demise of the working horse.

So the entire history of the cart-horse has been a long, slow haul: a centuries-long rehearsal for a few brief decades of applause. The story can be said to start with the invention of the rigid horse-collar in AD 700. Until then men had tried to put horses to work in the same way as oxen, which was by yoking. A yoke was a frame of wood with two loops or bows which went round the oxen's necks. As the oxen moved forward, the yoke went with them, and so did the load to which it was attached. With horses, the effect was disastrous: the horses simply choked. They would have reared in terror as the loops tightened round their necks, and

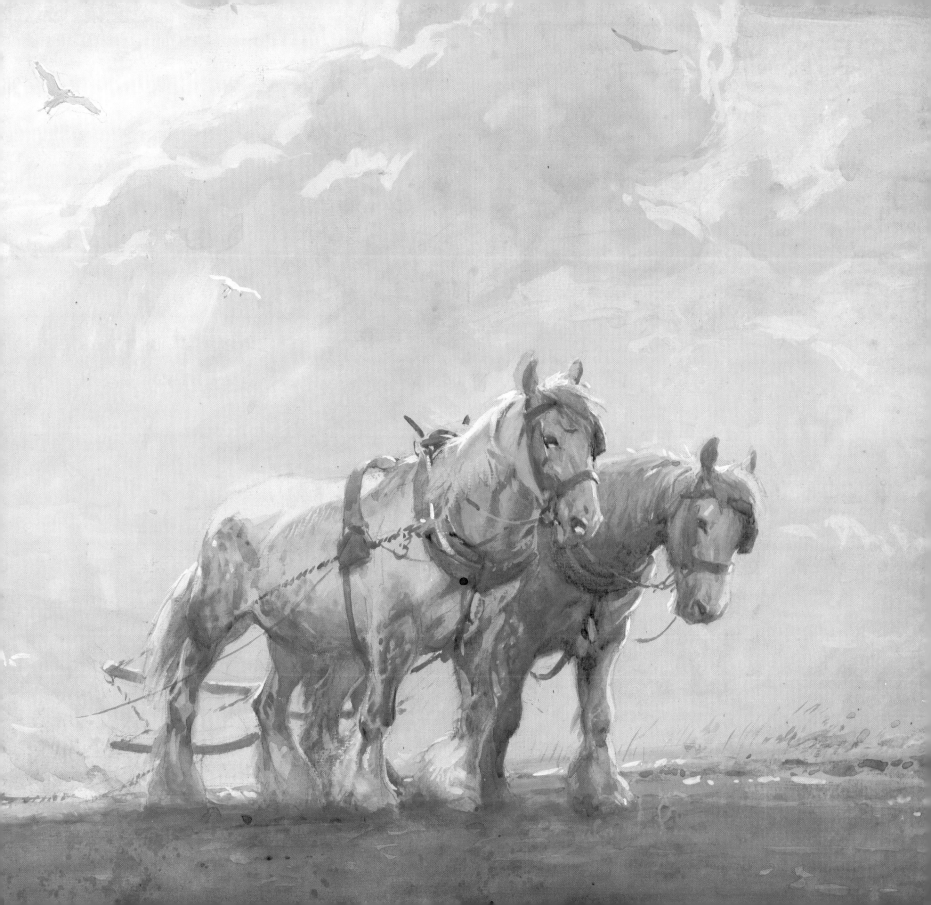

any forward pull they might have been able to exert would have been slight and gained only at the expense of damage to the horse's wind and courage. Only when it was realized that a stiff collar could be made which would rest not on the horse's neck (as it might appear) but comfortably on its broad shoulders, was the way clear for the horse to start his career on the land.

Three hundred years later the Bayeux Tapestry shows that horses had been put to simple work, such as harrowing, which was simply the dragging of spikes across the land to break up clods of earth and make it fine enough to receive the seed of the next crop. By now, Britain had good horses bred from stock left by the Romans; these were improved even further with the coming of William the Conqueror who brought not only fine horses from France but much advanced agricultural thinking which was to have a profound effect on the development of the cart-horse.

But even now, the cart-horse was destined to be second best – as it has been for most of its career. The biggest, most upstanding horses were reserved for carrying the weighty, armour-clad knights. Only those that didn't make the grade were sent to the land. Even so, the introduction of heavier strains was beginning to take effect, and the Luttrell Psalter of 1340 shows that harness had been developed, although still of rope. It also shows that as well as harrowing, horses were now hitched three-in-line in order to pull a heavily-laden waggon. However, the sacramental task of turning the old soil into new by ploughing remained the preserve of the oxen, who are seen hitched four to a plough. It was many years before the horse was able to take that vital task away from them.

In the 12th century, experiments had begun in trying to get the best of both worlds, by hitching oxen and horses together. Sometimes the unwieldy teams became as big as 16 or 20 animals. The battle for supremacy was to last for several centuries and was not really settled till the start of the 20th. It was not the efficiency of the horse that was in doubt, but rather the quality of the gear it was asked to haul. It was understood that

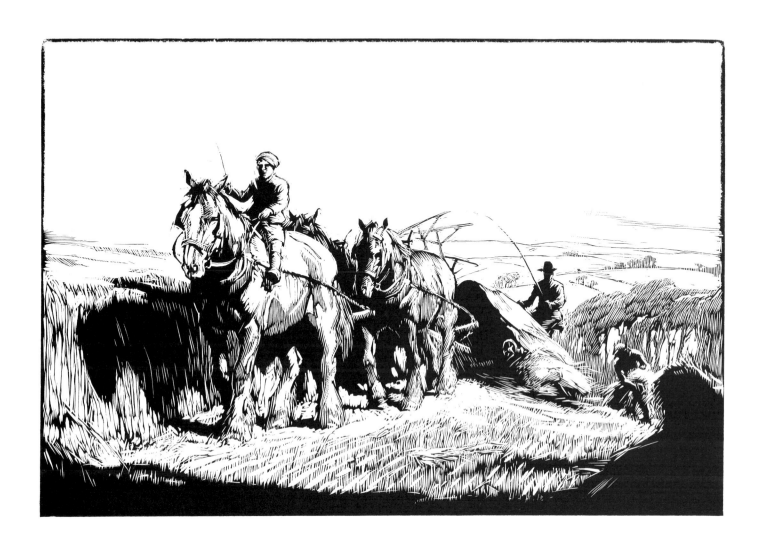

THE HORSES · 25

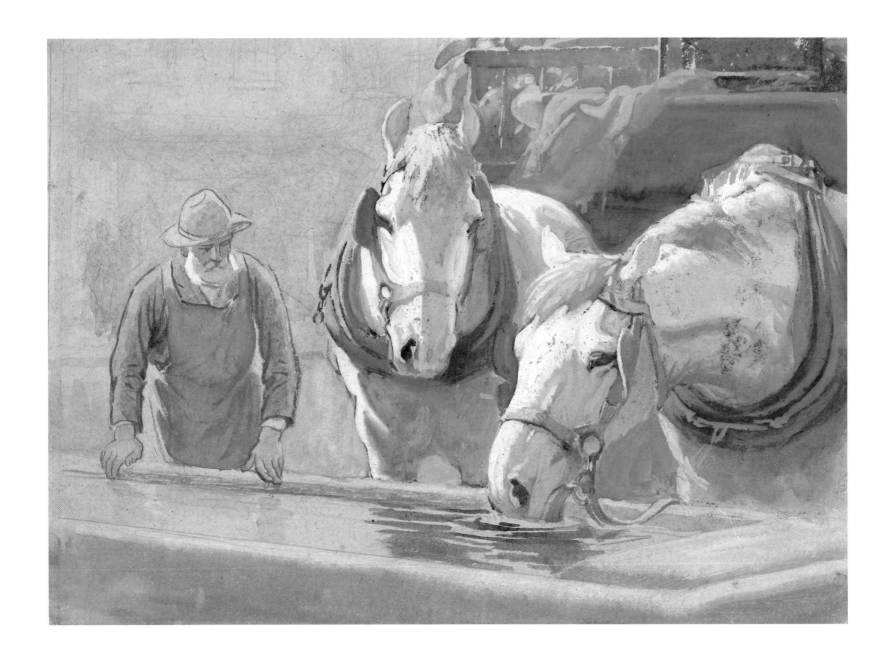

the horse was faster in his work than the ox, but the horse pulled less steadily and so the poorly designed gear soon broke. The horse, of course, was more expensive to keep – needing shoes on his feet and grooming before work to remove the sweat from his coat so that he should not become sore where the harness rubbed his salty skin. Even in death the ox scored, for after years of faithful, plodding service he delivered his master a fine tasty carcase and a good supply of leather. A dead horse was no more than waste. That was the conclusion first reached over 400 years ago. In his definitive book on agriculture written in 1571, Thomas Tusser, author of *Five Hundred Points of Good Husbandry* wrote:

> "The horse costs more than the ox . . . besides a plough of oxen will go as far in the year as a plough of horses because the malice of ploughmen will not allow the plough to go beyond their face, no more than the plough of oxen. Further in very hard ground where the plough of horses will stop the plough of oxen will pass . . . and it is usual and right that plough beasts should be in the stall between the feast of St Luke and the feast of the Holy Cross in May 25 weeks, it is necessary that he should have every night at least the 6th part of a bushel of oats price 1 half penny and at the least 132 penny-worth of grass in summer and each week more or less a penny in shoeing if he must be shod on all four feet . . . If the ox is to be in condition to do his work, then it is necessary that he should have at least three sheaves and a half of oats in the week, price one penny . . . and when the horse is old and worn out then there is nothing but the skin; and when the ox is old with tenpennyworth of grass he shall be fit for the larder."

Q.E.D., as they say.

Even so, it is surprising to discover that less than a hundred years ago, well into the golden age of the working horse, oxen still had their

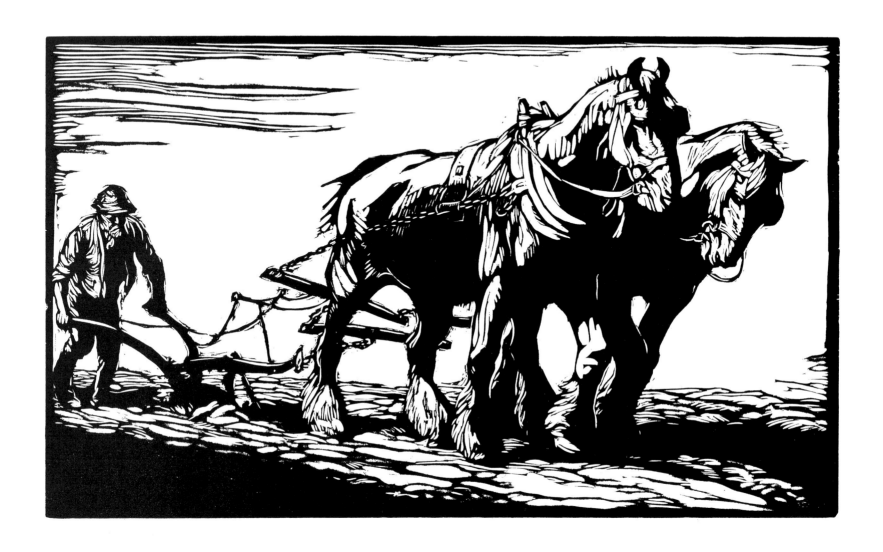

adherents. In his book *A Song for Every Season*, Bob Copper remembers life on his family's Sussex downland farm in the 1890s.

"The two bullock-teams were used a lot for rolling, for it was held that they did as much good with their hooves as the roller did in breaking up the clods into a fine tilth. The outbuildings included the bullock sheds which housed Luke's team of eight bullocks. Their names were Turk and Tiger, Lark and Linnett, Trot and Traveller and Buck and Benbow. When working, they were yoked up in pairs; the yokes were crude, hand-hewn affairs consisting of a heavy oak beam and two green ash bows to encircle the necks of the bullocks. They had not changed in pattern since Saxon days.

"Luke was a heavy, lethargic sort of man and his speed was well suited to that of his bullocks. Jim swore that sometimes Luke would follow behind them with one foot in the furrow, holding onto the plough handles, and drop off to sleep walking along. One day, when they were ploughing up at the Kompt, he was suffering a little from flatulence and relieved himself of gastric pressures with such violence that the sound, rattling across the morning air, prompted his team to pull up to a dead halt. 'C'mon, git on wid ye,' he bellowed, 'I didn't say nawthen, I only got rid of a liddle wind. I dunno, you'll soon be cunning enough to be Almanack makers.'"

The ox may well have been more cunning than Luke suspected, for without the intervention of the agricultural engineers of the 18th and 19th centuries, he might well have eclipsed the working horse right up to the invention of the tractor.

Thomas Coke of Holkham, the greatest "improver" of all time, revolutionized agriculture in Britain by searching abroad for innovation with which to experiment on his north Norfolk estate. He introduced manuring to improve the starved land and grew wheat in quantity where poor crops of rye had been grown before. He was the first to grow swede

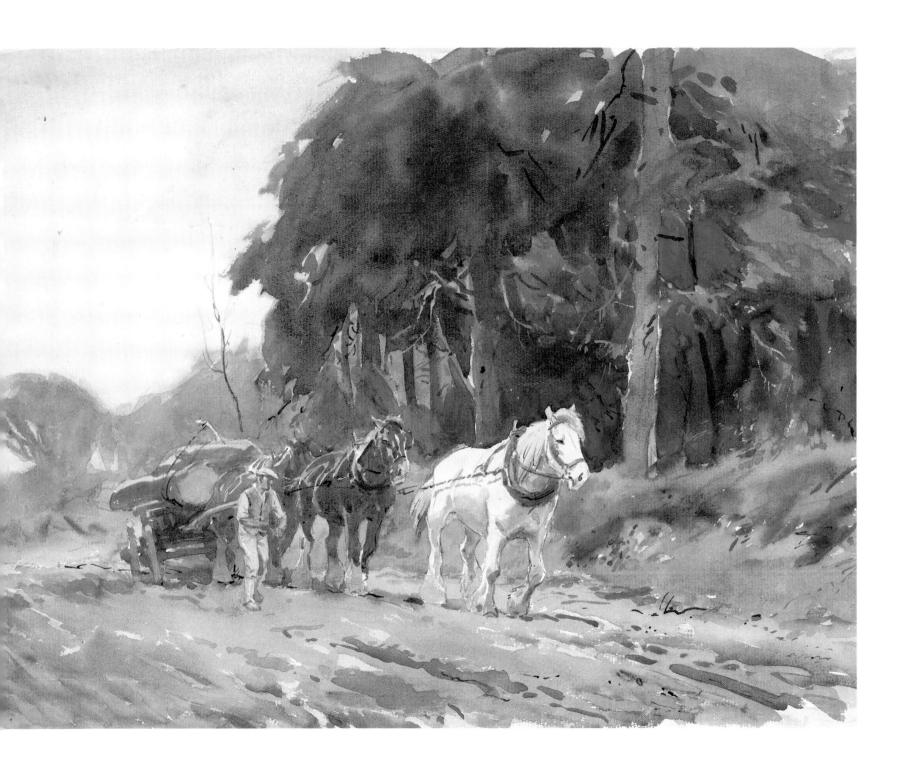

turnips on a large scale and hence the first farmer to discover a rich source of winter fodder for his sheep. But more importantly, aided by the earlier invention of the light iron Rotherham plough in 1730, he showed that two horses and one man could plough better than six oxen in the charge of a man and a boy. This was another major turning point in the history of the farm horse, and from that time onwards you find that fields were laid out to suit the comparative agility and manoeuverability of the horse rather than the ox.

As fertile minds invented horse-drawn mowers that could cut grass to make hay, rakes to drag it together, and turners to speed its drying, the horse rapidly took charge of farming operations in England. The invention of the ultimate in mechanical ingenuity, the horse-drawn binder, must have seemed a miracle to the men who would otherwise have had to labour hours over the job which this contrivance now did for them.

The binder, which needed three horses to drag it along, was a harvester. By way of cogs, chains and gears it converted the steady plod of the horse into a mechanical motion that could cut the standing corn, squeeze it into tight bundles and even throw a string around it and tie it in a knot. When it had done all this, it threw out the sheaves it had made ready to be "stooked", thus creating the famously evocative and typical sight of the cornfield after harvest. So complex was the device that threw the twine around the sheaf and knotted it, that having invented it, the inventor himself did not even understand how it worked. It is claimed that the turmoil this engendered in his bewildered mind led him to suicide.

The horse and the ingenious equipment he now pulled looked set fair to plod into, and through, the 20th century. It is estimated that their peak came in 1910 when there were then a million horses working on the land. Four years later, half of them were to die on the battlefields of Europe.

But the First World War was not the end of the working horse. It had taken him centuries to rise to his zenith and he did not give up his hard-won position that easily. His decline was a slow one; it is our good

fortune that the days when the farm horses of England were working in their greatest numbers were also the days when George Soper was at his most prolific.

If a popularity poll were conducted as to which particular breed of heavy horse was most firmly in the hearts and minds of the casual observer, the Shire horse would win it, hands down. To most people, the farm horse *is* the Shire horse. There is no other. By virtue of its benign, doleful looks and its fluffy, feathered feet, it has won its place on the Christmas card and the chocolate box to the exclusion of the often forgotten but equally praiseworthy Clydesdales or Suffolk Punches.

But as any farmer will tell you, good looks are not everything in a working horse. Temperament has to come top of the list, and willingness to work, and sheer strength. No matter how many cups or medals a horse may have won, he was no use on the farm if he was slovenly or idle when put between the shafts. Nor could many farmers afford to keep a horse simply for its shape: it would have been beyond their means. And so although much is made of the gigantic, upstanding Shire horses as seen in glistening harness parading at Royal Shows, the truth is that these have never represented many of the horses that worked on the land. They were the generals who left the hard work to a huge army of squaddies of mixed and indeterminate breed.

The working horse of Soper's day was much smaller than his glossy brothers of the modern show-ring. If you go to an auction today where old horse-collars from the 1920s and '30s are being sold, very few would be large enough to fit a modern heavy horse. In many ways, the smaller horse was a good thing: its shoulders, from which it pulled, were nearer the ground, which made it more efficient in draught. Purity of breed was not always an advantage either. In the same way that many people believe mongrel dogs make more placid pets, there was a widespread belief that a good mixed horse, perhaps a combination of a heavy and lighter horse, was a "good old hoss" for land work. "Half-legged", they were called.

Britain has three pure breeds of heavy horse that it can call its own,

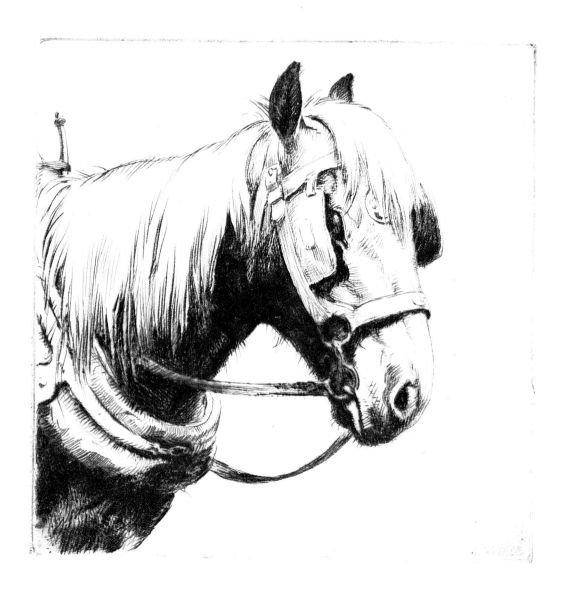

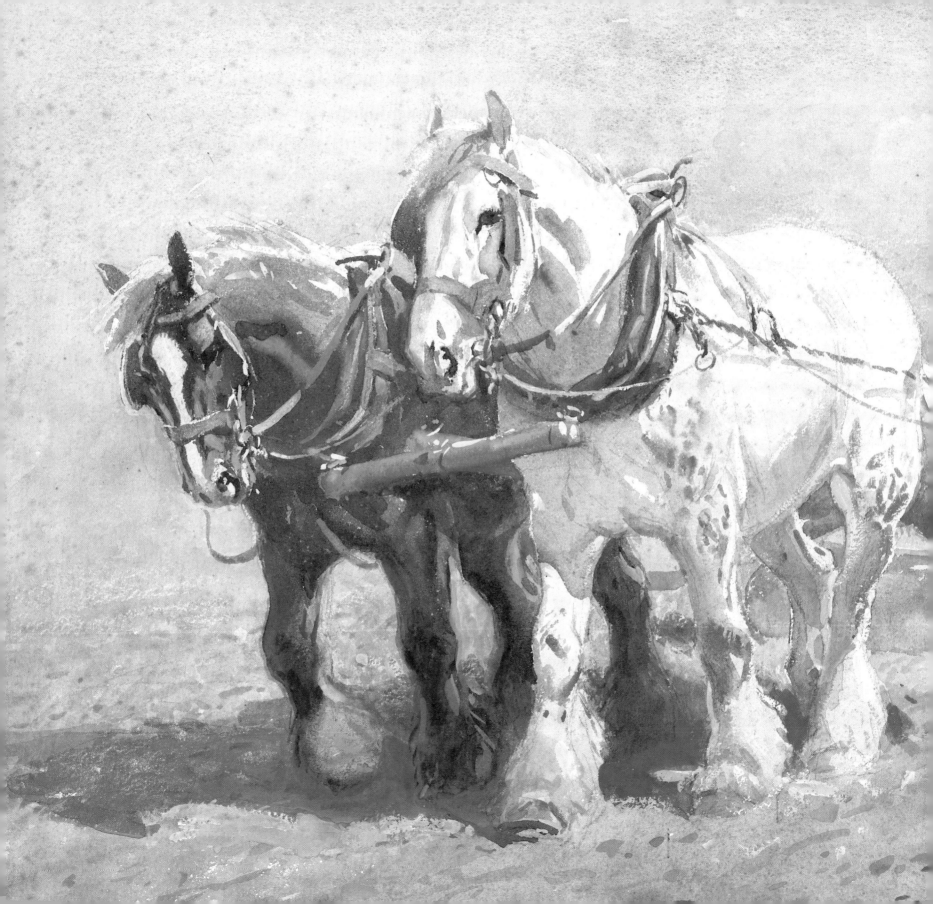

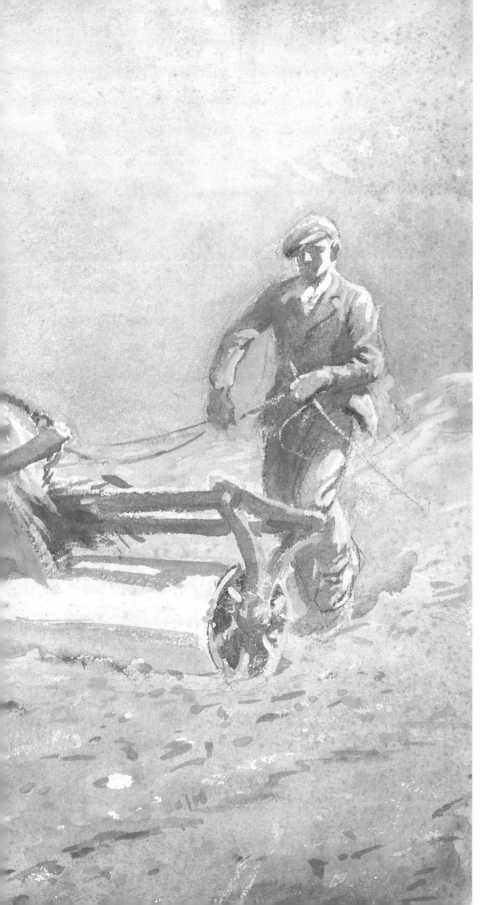

and it would have been a mixture of these that George Soper saw at work on the land. Had he drawn and painted in the Midland counties of Leicestershire, Nottinghamshire or Derbyshire, he would have seen principally Shires, for this is generally reckoned to have been the Shire's home territory.

The history of the Shire horse is murky, and any attempt to go further back than the middle of the 18th century is like a heavy haul along a muddy field: you get bogged down. However, the Packington Blind Horse, a noble stallion, is well described. He travelled widely in order to cover mares and his journeys are first recorded in 1755. His name is mentioned in some very old pedigrees making him one of the earliest Shires to be recorded. He was a very prolific stallion who left other good stallions behind him, and his offspring in direct line were still very much in evidence 80 years after his birth.

It has to be remembered that good fees were paid by farmers for the use of a stallion to cover their mares, and at one stage in the history of farming economics, a farmer with a good stallion could expect to make as much as a man's wages for a whole year out of stud fees.

In the days before the horse-lorry, however, the stallion travelled on his feet. An itinerary would be published beforehand of where the horse would be on certain days. It was then up to farmers to arrive with their mares at the appointed hour. The stallion's circuit would be organized so as to bring him home by the weekend, after which he would be off once again on his rounds. His handler, or leader, would of course walk with him and the roller or leather belt that the stallion wore around his girth would have straps and buckles with which the stallion's handler could fasten a few personal items, like a sleeping rug. It was a job of great responsibility since the stallion was obviously of great value; but it must also have been an occupation of both great temptation and deprivation, for many of the stallion's advertised stopping places would have been inns and public houses with all the warm lures they offer a man who has been hours alone on the road. These men must also have spent as many

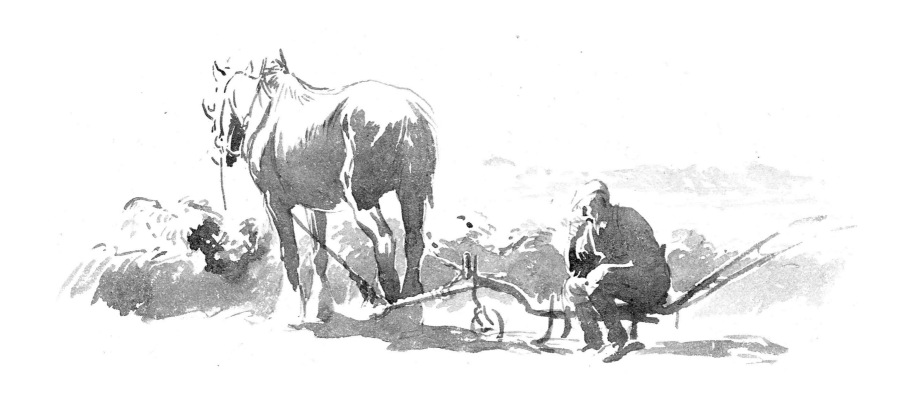

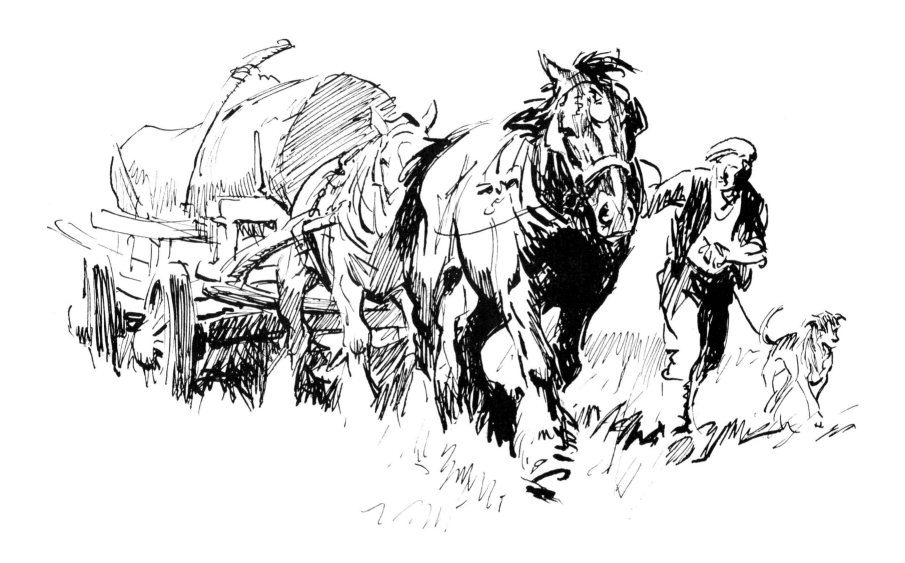

nights sleeping in damp, draughty stables with their stallions as they did at home with their wives.

Until the introduction of a stud-book and the formation of the English Cart Horse Society (which became the Shire Horse Society) there was no real breeding policy for farm horses. A good stallion would cover a farmer's mare but after that, any mares produced would be covered by any unrelated stallion available. But demand from America, rebuilding after its Civil War, meant that horses with a recorded pedigree were in high demand. Farmers are never slow to spot a good trade when they see one and so with one eye on the export market, the business of breeding Shires started to gather momentum.

There was much rapid improvement, which was needed. The Shire breed had come to be associated with short, upright pasterns which gave rise to sidebones and thick, fleshy legs which were notorious for developing a vile skin disease called "grease". The first signs of this would be a stamping of the hind feet and the rubbing of one leg with the sharp edge of the shoe of the other. Oily fluid would seep from the chafed skin and matt in the hairs and give rise to a "disagreeable, fetid odour". After a time, the skin would swell and bubble and hang in what would be called "grapes". If injured, these would bleed and leak a vile-smelling greasy substance signalling, in extreme cases, the end of the horse's working life.

It is amazing to discover that almost within a generation, skilful breeders managed to correct so many of the faults with the Shire horse and by the turn of the century could boast such fine stallions as "Harold" described in *Vinton's Livestock Handbook*:

> "First and foremost, he is a thorough stallion all through, and there is no possibility of mistaking him for one of the weaker sex at any point; secondly, his commanding size and tremendous bone; and thirdly, in action he is especially good when leaving you, and impresses one with the idea of never-failing courage and fire. These qualities he certainly transmits to all his progeny in a remarkable

degree, while he possesses the rare qualification of getting mares and stallions equally good."

The author of this hymn of praise remarks, ". . . it was indeed a happy day for the Shire Horse when he went down into Worcestershire instead of crossing the Atlantic Ocean."

Of all three native breeds of British heavy horse, the Clydesdale is the most mixed bag. Its fans say its mixed parentage is the horse's greatest strength, for it has taken the best points of all heavy breeds and blended them into the finest heavy horse that ever lived. Shire and Suffolk have few bards: but the might and majesty of the Clydesdales have moved one man at least to verse:

> Blue blood for him who races,
> Clean limbs for him who rides,
> But for me the giant graces,
> And the white and honest faces
> The power upon the traces
> Of the Clydes!

I do not know how the Scottish poet, Will Ogilvie, became besotted with Scotland's native breed but it was a considered love affair, for in another of his verses he considers the other breeds, and dismisses them:

> The Suffolk Punch will keep the road,
> The Percheron goes gay;
> The Shire will lean against his load
> All through the longest day;
> But where ploughland meets the heather
> And the earth from sky divides,
> Through the misty Northern weather
> Stepping two and two together,
> All fire and feather,
> Come the Clydes!

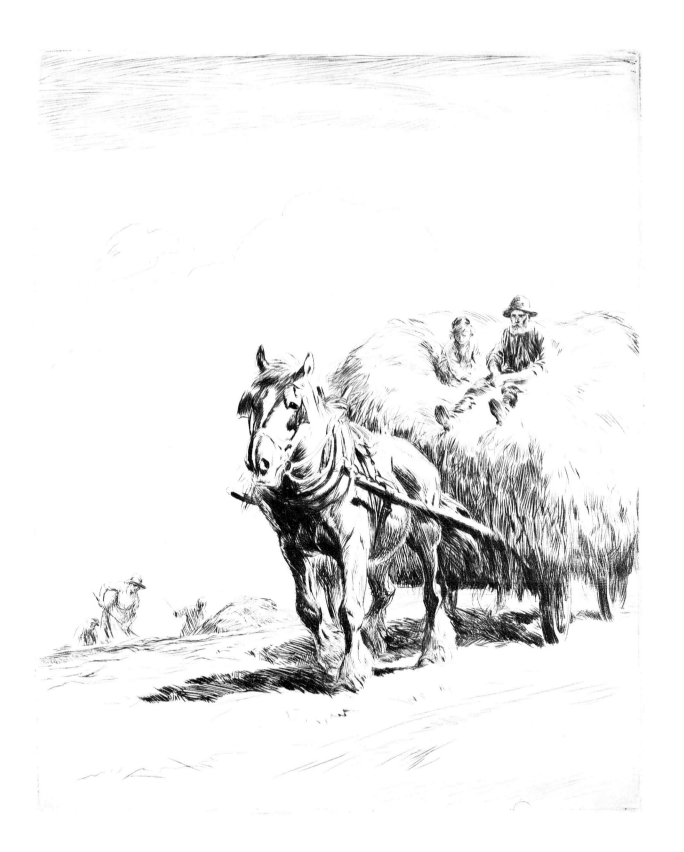

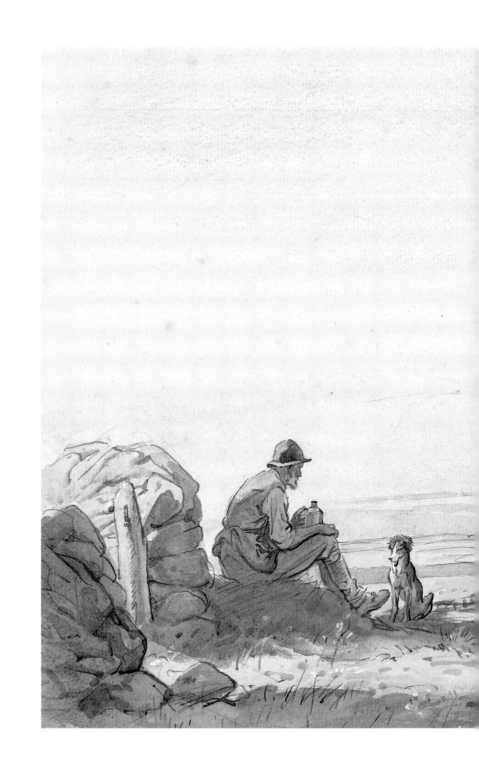

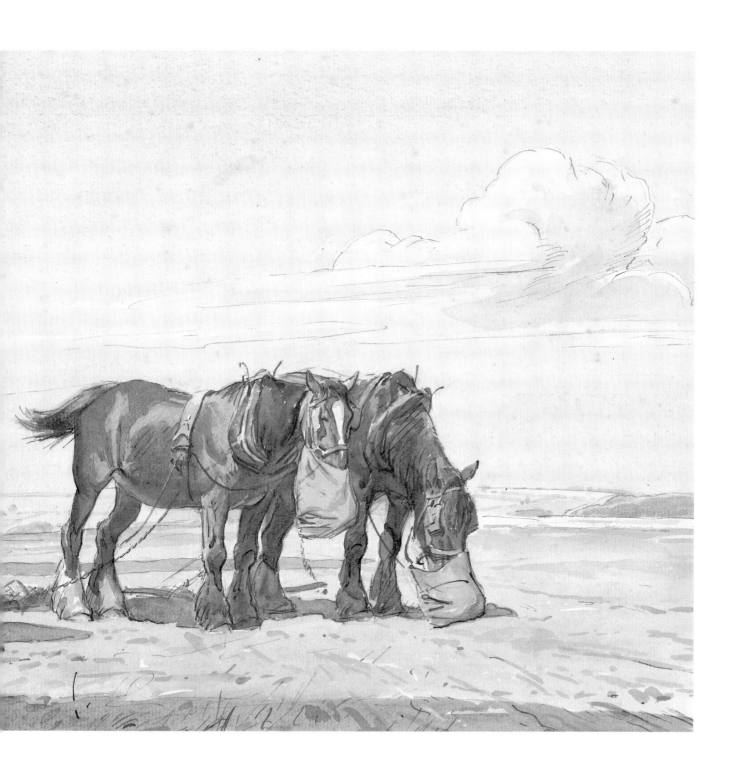

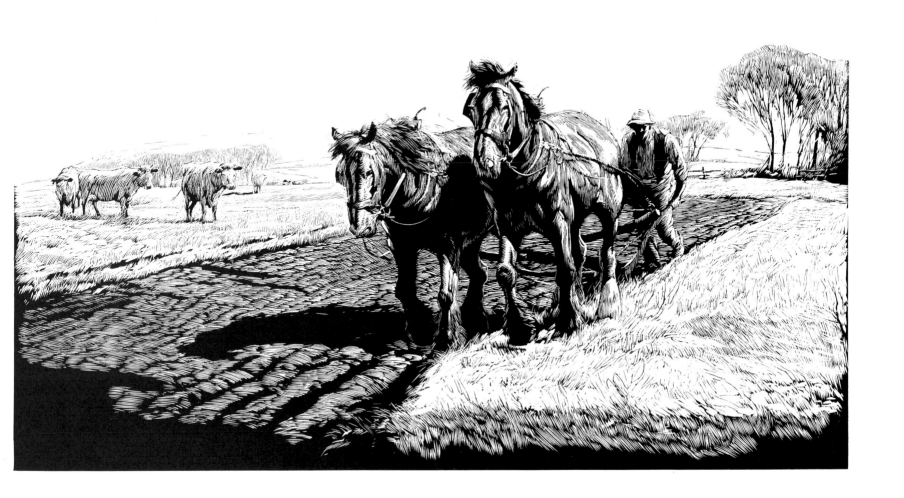

Ogilvie has captured the might of the plodding Clydesdale horse in the rhythm of his verse: other breeds might well envy the tribute.

It is said that the Clydesdale represents a refinement of a native breed of horse from the Scottish lowlands; a thick, heavy, short legged but active animal. It was once thought that the Duke of Hamilton introduced Flemish stallion blood in the mid 18th century, but that is now thought not to be the case. What seems to be true is that in 1715, a Mr Paterson imported a Flemish stallion. Many years later, a descendant of his sold a mare to a Mr Somerville of Lampits Farm. There seems every reason to believe that this mare must have been related to the Flemish stallion. A foal out of that mare was called Glancer and became known as Thomson's Black Horse and the author of the *Cyclopaedia of Agriculture* (1907) claimed that every Clydesdale horse could be shown to be related to her.

Inevitably, blood lines crossed the border and Shire blood was introduced to increase the size and weight of the Clydesdale. It reached the point where Shire supporters said that there was now no difference between the breeds, but of course, the Clydesdale men thought differently.

A crisis occurred around the turn of the century when it was suddenly realized that so much breeding had taken place that they were losing from the Clydesdale the very things they admired in it. It was beginning to lack the "cart-horse character". The situation was saved by a horse called Sir Everard. His pedigree was Clydesdale through and through and according to a description of him in Archibald Macneilage's *Livestock on the Farm*, he had more than enough "cart-horse character" to go round:

"He was masculine horse of weight and substance. Foaled in 1885, in March 1891, he stood fully 17.1 hands high, girthed in ordinary condition 8 ft., and weighed $20\frac{3}{4}$ cwt., or 2324 lbs. He measured 26 in. round the upper muscles of the forearm, 17 in. round the knee, had 11 in. bone below the knee, and 12 in. bone below the hock. He was a horse of great depth of rib with a short back and splendid quarters and thighs. The formation of his hind leg was faultless, and

in front he stood well up at the shoulders, his withers being high and well furnished with muscle. His neck was perhaps rather short, and his fore feet might have been stronger. Taken in all he was a most massive and weighty cart horse."

We can only speculate as whether it was a horse such as Sir Everard that again moved the poet Will Ogilvie to write about the Clydesdale stallion as he travelled to cover his mares:

Beside the dusty road he steps at ease;
His great head bending to the stallion-bar
Now lifted, now flung downward, to his knees,
Tossing the forelock from his forehead star
Champing the while upon his heavy bit in pride
And flecking foam upon his flank and side.

Save for his roller striped in white and blue
He wears no harness on his mighty back.
For all the splendour of his bone and thew
He travels burdenless along the track.
Yet he shall give a hundred hefty sons
The strength to carry what his kingship shuns.

It is a wise man who knows his father: and of all the three breeds it is the Suffolk Punch who can best lay claim to knowing his. Every Suffolk horse alive can trace its parentage to Crisp's Horse of Ufford which foaled in 1768. And there the matter rested till recent years when a major upset rocked the Suffolk Horse Society. It was suggested that Crisp's Horse of Ufford was really Crisp's Horse of Orford. Now, Ufford is a small village about 10 miles north of Ipswich and nestles in the valley of the River Deben. Orford lies a river's breadth away from the coast and was once an important trading town because of its coastal position. In 1768 a

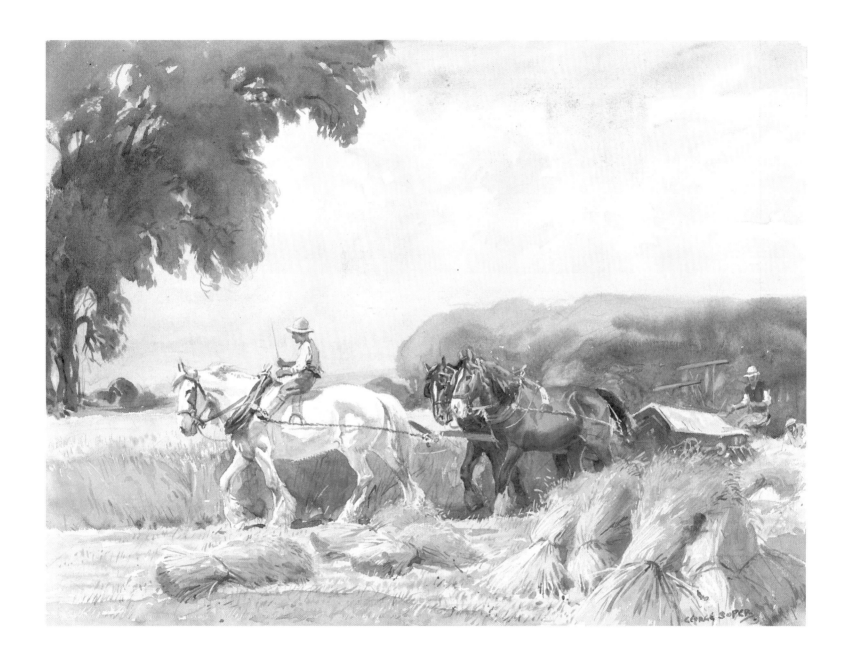

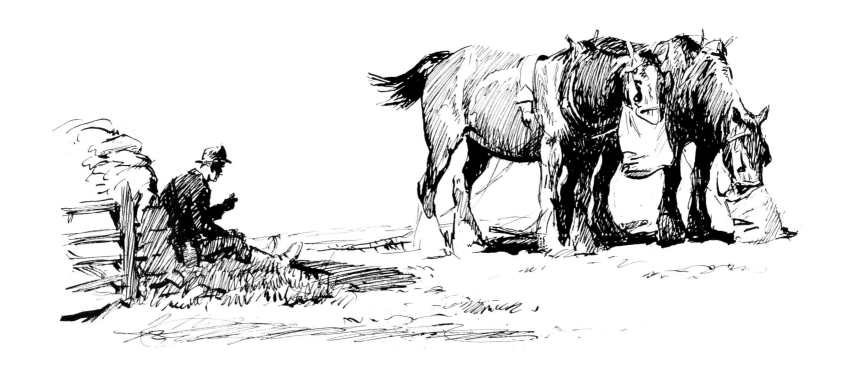

Mr Crisp, a farmer, did indeed reside there and this lent credence to this new theory about the parentage of the Suffolk horse. For a time, the breed society was rocked, as societies tend to be by such upheavals. The argument was resolved when records were examined which showed the horse could only have stuck to his timetable whilst travelling if he had set out from Ufford, and not from Orford. Crisp's Horse of Ufford won the day.

But debate has always hovered around the Suffolk Punch. Of all the three breeds, the beauty of him resides most in the eye of the beholder. He is an acquired taste. The great agricultural observer, Arthur Young, wrote of the Suffolk Punch in his report to the Board of Agriculture published in 1797:

> "I remember seeing several of the old breed which were very famous; and in some respects an uglier horse could not well be viewed; sorrel colour, very low in the fore-end, a large ill-shaped head, with slouching heavy ears, a great carcase and short legs; but short backed. These horses could only walk and draw; they could trot no better than a cow."

However, a description of the Suffolk Punch written by John Lawrence in his *History of the Horse* not many years later paints a different picture:

> "The old Suffolk Punch or cart-horse was, I think, beyond all question the most active, steady and powerful draught horse in existence."

A different eye beheld a different horse.

For a cart-horse, the apparently odd shape of the Suffolk Punch did have advantages. It derived its strength from the lowness of its shoulders and its deep-ribbed carcase was a great advantage in that it could work long hours without food – essential for long working days on the

corn-growing lands of East Anglia where harvests had to be taken while the sun shone, even if it meant the horse working from seven in the morning till three in the afternoon without a break.

But perhaps one of its greatest advantages was the lack of feather on its feet. Delightful though a groomed feathered horse may look, from the point of view of working on the heavy, sticky clay land of East Anglia feather was a curse. The Suffolk, having none, meant a lot less tedious work for the horsemen in keeping their animals' legs clean and tidy. It is interesting to note that modern Shire horses are now bred to carry much less feather than in the days when there was a large and lowly-paid work-force to keep occupied.

In the early part of this century, the Suffolk Horse Society went to great lengths not only to encourage the breeding of better horses, but also to put good horses in the hands of smaller farmers who might not be able to afford them out of their own pocket. A farmer could apply for a mare which would be sold to him by the Society. The mare would not cost more than 60 guineas, although the farmer would only pay a deposit of a quarter of that. On the balance, he was charged interest at four per cent. When the mare foaled, the farmer would get £16 10s. for it which would help to repay the original loan. If the foal then sold for more than £20, the farmer would get half of anything over and above the £20 so as to encourage him to take good care of his mare and breed good, sound foals. It was a good scheme which no doubt helped with the breeding of good stock and put pedigree horses on farms which would otherwise not have been able to afford them. We probably owe to it much of the present health and utility of the breed.

The Suffolk Punch is always chestnut in colour; but it is not quite as simple as that. Tradition, for whatever reason, always spells it "chesnut" and chesnut itself is a broad description for what are said to be seven different shades; although there are very few experts who could tell one from the other. In the *Suffolk Stud Book*, Herman Biddell describes them thus:

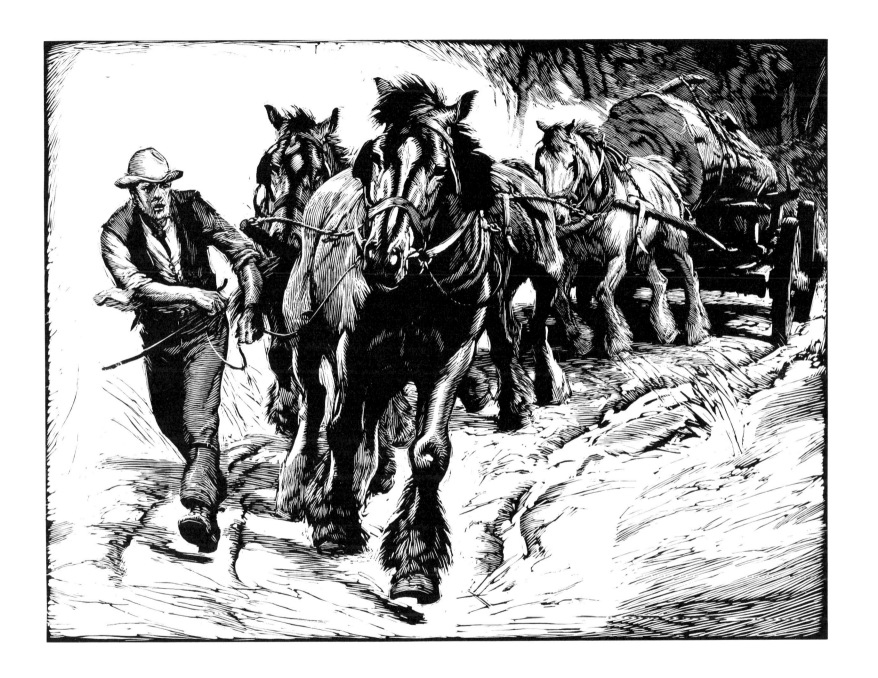

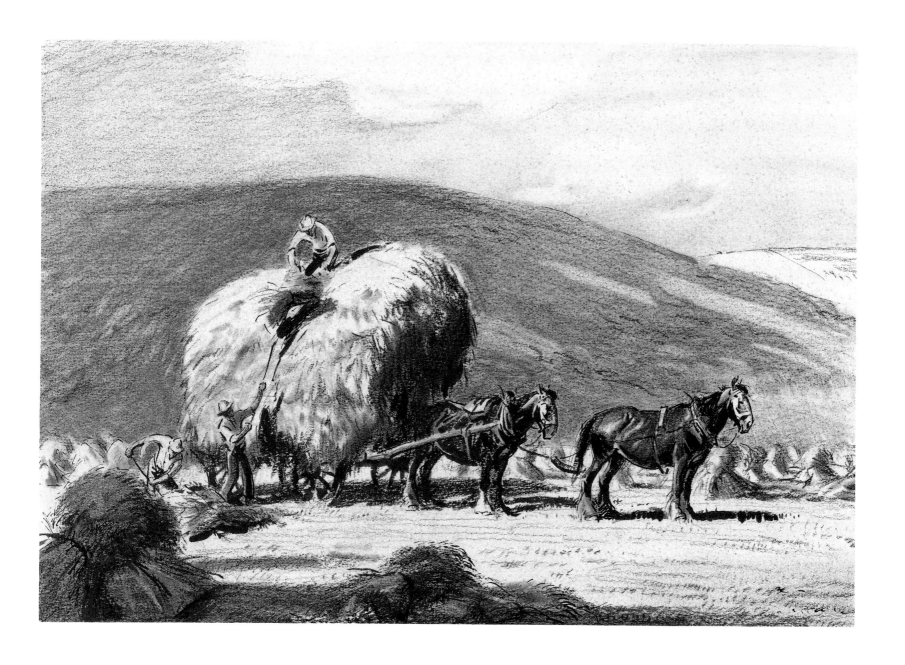

"Of the chesnut there are seven shades – the dark, at times approaching a black-brown, mahogany, or liver colour; the dull dark chesnut; the light mealy chesnut; the red; the golden; the lemon, and the bright chesnut. The most popular, the most common, and the most standing colour is the last named."

Biddell was the author of the first *Suffolk Stud Book* published in 1880 and it is clear from his meticulous and often heart-breaking researches (he once arrived at a farm just in time to see the pedigree records that he searched the county for being thrown onto the bonfire) that his love for the Suffolk Punch ran deep. In the closing paragraphs of his long, loving and technical descriptions of the breed, he rises to a great crescendo:

"The Suffolk horse is an agricultural horse, and is bred for agricultural purposes: the dray horse – the modern Shire-bred – although used on the farm is raised as an article of agricultural produce. The two animals have their proper spheres: on the docks at Liverpool; at the siding on the railway; or the heavy drays in London, the large edition of the 'English Cart Horse' is in his place. For all purposes of British agriculture, the Suffolk horse, smart between the shafts in harvest; quick at the ends on the plough; a fast walker on the harrows after the drill, and a staunch slave at the collar, be it flour, timber or chalk behind him, is unsurpassed by any breed of horses in England or Scotland either."

3

THE HORSEMEN

THE CART-HORSE dominates any farming scene in which it is set. Even when at rest it catches the eye, its resting power and sheer obedience having a fascination all of their own. When at work, the precision with which it can walk unfalteringly along the furrow, or the might it can exert to draw trunks of newly-felled timber, eclipses all else. The artist's first duty must be to the horse; for the cart-horse is the undeniable star of the show.

And George Soper did him justice. He caught the cart-horse in all its moods whether they be of willingness, cussedness, exhaustion or triumph. But unlike many other artists of his time, he did not ignore the horseman; the lonely figure following behind a team in the furrow or urging a tired and laden horse along muddy, rutted tracks as he carts the last load of the day.

In the days when horses were supreme, the horseman was the key to success. He may not have been the farmer or the landowner. Indeed, he was no more than an employee, but it was widely understood that the head-horseman (or carter, or waggoner, depending on which part of the country you happen to be) was the king of any farm on which he worked. A good horseman was to be prized and wooed, for without a reliable man to feed and tend a team and to deploy the skill of breaking new horses for work, then the cart-horse was just so much flesh and bone.

The horseman had privileges and commanded respect. He was always the first man to leave the yard with horses when heading for the fields; and after a day's work was done, no man would leave the field without

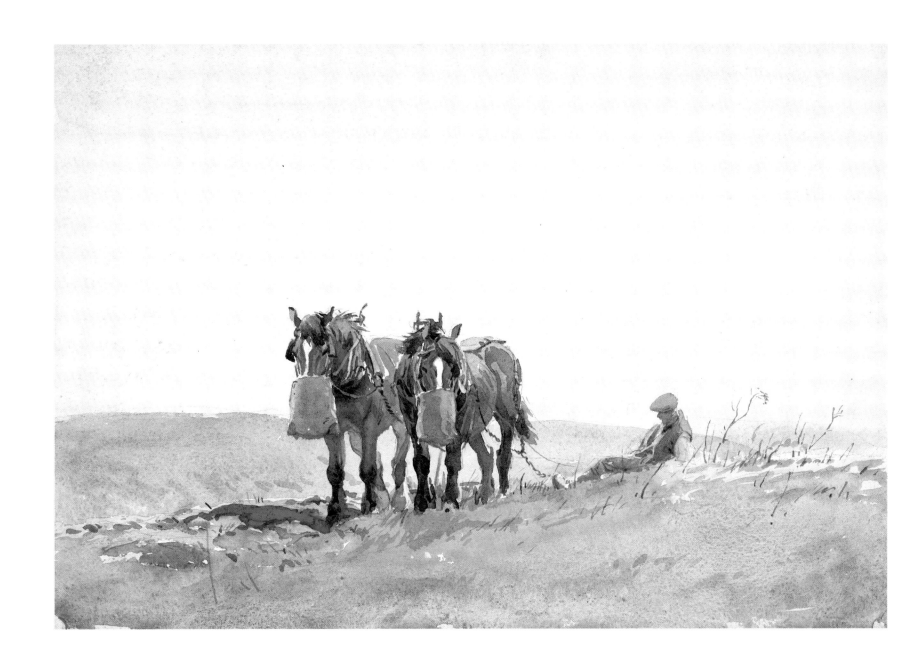

his permission. To bolster his authority, he had secrets which would have been handed down from father to son. He would have, in his head, recipes for potions which would calm wild horses or coax young ones, revive old ones or, for mischief, stop horses dead in their tracks. William Cobbett writing in the early part of the 19th century said of the horseman, or carter:

"A carter is the sole master of the horses with which he goes; and, in nine cases out of ten, he is, as far as concerns them and their labours, pretty nearly the master of their owner. He must have his way pretty much as to quantity and quality of food, as to hours of labour, and as to various other things, in which, if you do not give way to him, you must make up your mind to get rid of him; and, even then, you only exchange one sort of half master for another. If you be peremptory in your commands to him, and insist upon such or such a space of time, and also insist upon having your own way with regard to the food of the horses, he has a way of making their rough coats and bare bones convince you, that he understood these matters a great deal better than you."

Strangely, it was considered to be the mark of a good horseman that he would not be above stealing extra food for his horses. It has to be remembered that the farmer's principal interest was his profit and to that end, he would feed his horses not an ounce more than was needed to keep them alive and fit enough for work. It would have been in order to give a fattening bullock or lamb an extra handful of feed, for at the end of the day the farmer might see a return when the animal went to market. But the horseman simply wanted to have cleaner, fatter and fitter horses in his care than any other farm in the district. George Sadler was a Cambridge farmer's son who could not contemplate giving his horses anything but the best. He would help himself to linseed cake which was intended for sheep:

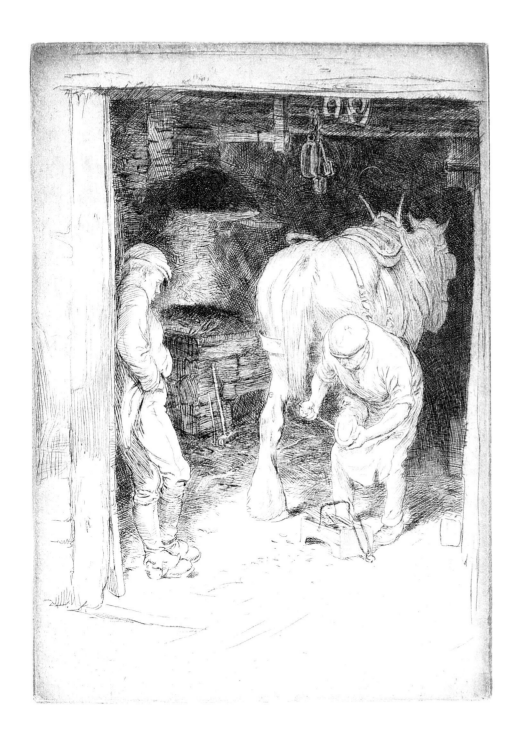

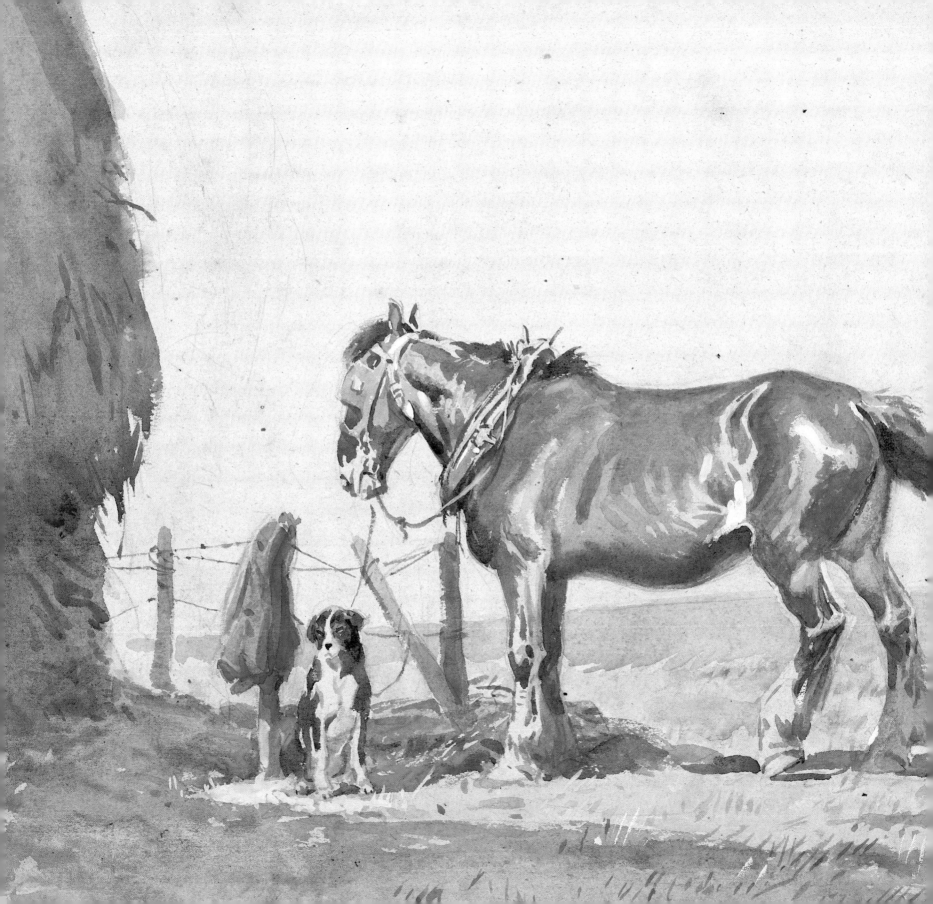

"I'd give it to the horses early in the morning before anyone got about. They'd eat that first and nobody would know. There's nothing like linseed cake for putting a gloss on their coats."

When he was found out, he stole beans, which had been bought for the lambs and once again he was caught:

"But I wasn't satisfied even then. One of my brothers used to look after cattle; and of course he had all the grub he could get hold of. And I used to go and start pinching the grub out of his tubs to feed to my team of horses. Well, I started pinching his cattle food, and he soon guessed what was going on, and he put a bloody rat-trap in one of his big barrels. And the next time I went to scrape out a pailful of this bullock's grub I got my hand in this trap. But even after that I went in pinching food for my horses. I really couldn't help it."

By modern standards, horsemen worked cruelly hard days. It would not be unusual for them to be up from their beds at four or five o'clock; a modest half an hour later would be allowed on winter mornings. Horses would be groomed and fed, often having three small feeds before breakfast time on the principle that "little and often" is the best way of feeding. Harness would have to be put on and, in the depths of winter, the men and their teams would be on the field before full daylight. They worked till 11 in the morning and then it was time for "bait". It seems to have been often bread, cheese and cold tea from an old beer bottle, and this had to keep them going till three or four in the afternoon even though they might be trudging long, heavy miles down sodden, slippery furrows. Routines varied in different parts of the country. The schedule just described was common in East Anglia but in other parts it would be usual to bring the horses back to feed at the middle of the day.

Horses had to be fed when they came back from the fields, harness removed and the sweat of the day's work brushed from their backs when

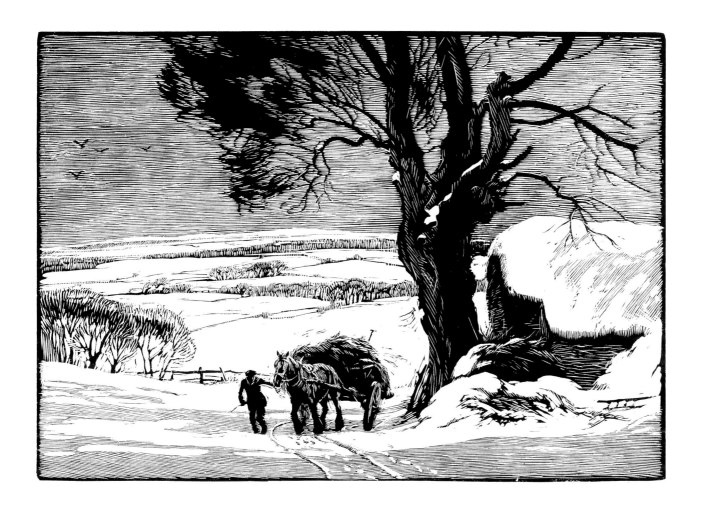

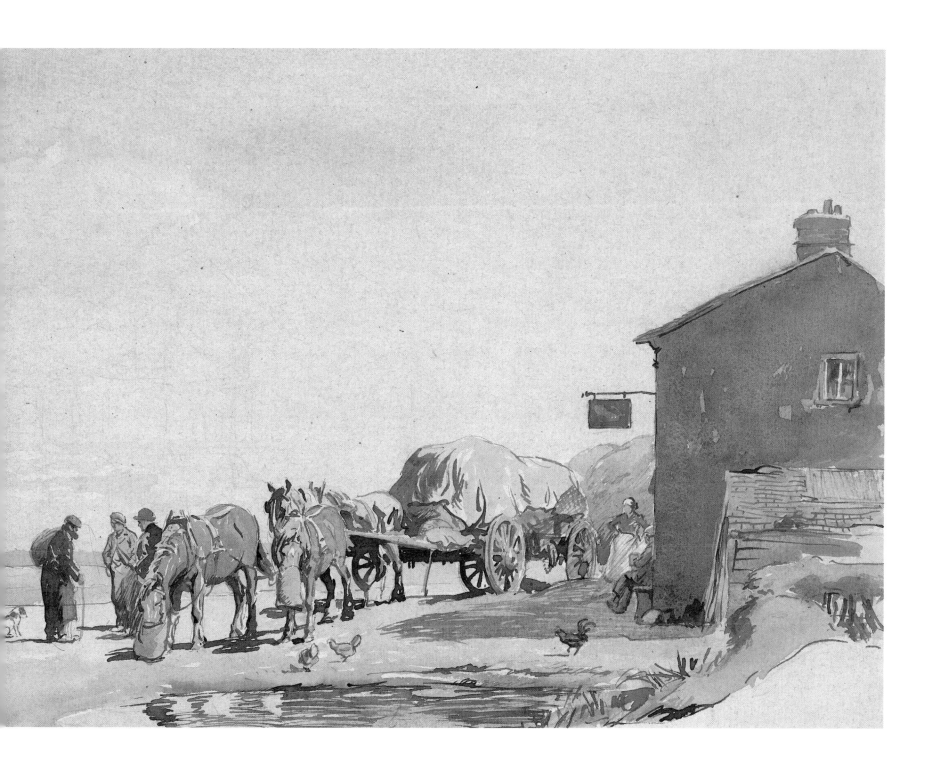

dry. The horseman could at last take himself home for tea, a full 13 hours since he had left home. But his work was not yet done. He would return to the stables about seven and "rack up" the mangers with hay to see the horses through the night. As one old horseman once told me, "you didn't need rocking off to sleep after a day like that."

It is not surprising that after spending the best part of 12 hours a day with their horses, horsemen knew every mood, every vice, every habit of the horses in their charge. In fact, they knew more about them than the farmers did and it was this deep, often instinctive knowledge that gave a horseman, or carter, his position of authority on the farm. In his memoir of his East Anglian farming days in the 1930s and '40s, Adrian Bell remembered how difficult it was to persuade his horseman, Jim, to make full use of a new horse called Prince. Jim's favourite work-horse was an old mare called Kitty.

"When my old mare Kitty came home tired from the plough or the dung cart, Prince would bound to meet her at the horse-yard gate. He would escort her to the stable, snapping playfully at her neck. 'What have you been up to all this time, to get you in that sweat?' 'Work.' 'What's work? You're always talking about work.' 'You wait, you'll see,' said Kitty.

"Time passed, and Prince laughed at the idea of work. The old horsekeeper did not seem to have any intention of making Prince work. Every morning the harness would be put on Kitty, and her tucked-up and rather drooping body expressed a deep sigh: 'Why always me? Look at that fat, hefty young thing at your side.' Prince pranced after her through the yard. 'If you don't like it, why put up with it?' And Kitty put her ears back, showing the whites of her eyes. 'You wait.'

"It seemed as though Prince might wait, and mock, for ever. Kitty had become a habit with the old horsekeeper, like the cobwebs on the ceiling that were never swept down, and the broken forks and

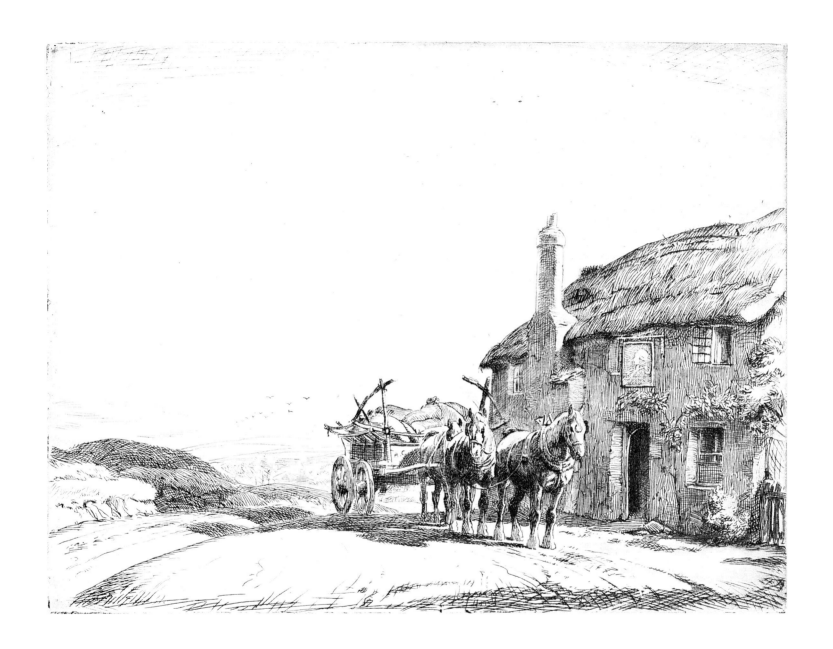

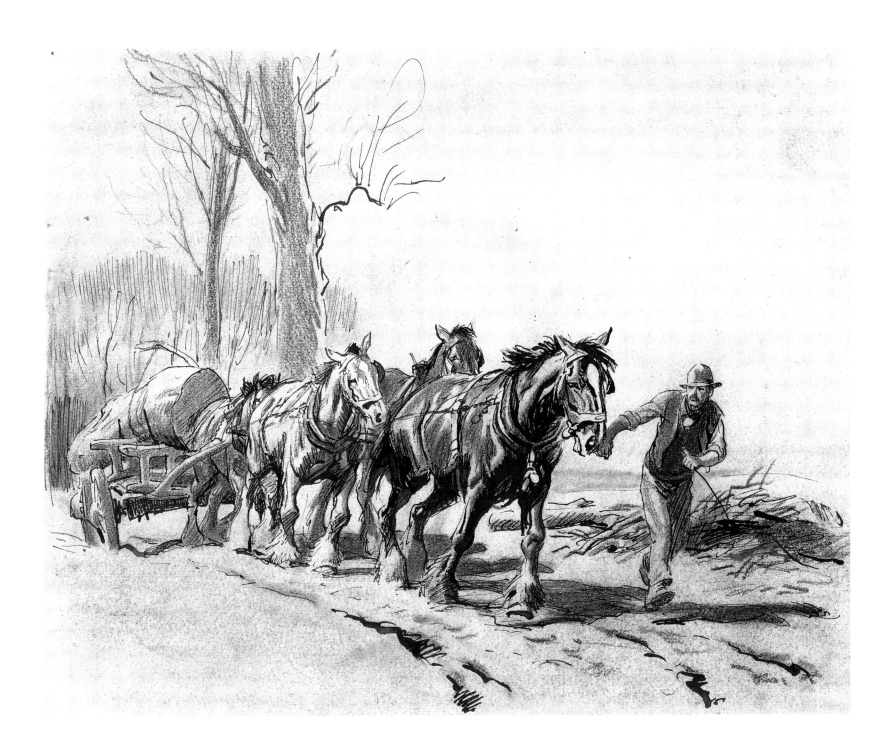

the worn-out horsecollars, that were useless but never thrown away . . .

" 'This won't do. Prince must be put to work,' I said.

" 'There, did you hear that?' expressed Kitty's ears.

" 'We've not a bit of ground suitable,' objected old Jim from a dark corner.

" 'What do you mean?'

" 'There want to be a bit of real rough ground to take him on for a start.'

" 'We'll make a fallow of Spring Field : that'll be rough enough.'

" 'That's too hard; we need a rain to soften the clods,' said old Jim. A good soaking rain soon came.

" 'Tomorrow we'll start to break him in.' Old Jim had nothing more to say, but looked funereal.

"The next morning when I came into the stable, old Jim still tried to look funereal. He said, 'Prince has hurt his foot: he's cut it somehow, just above the hoof.' Together we wondered how he did it. Probably against the corner of the water tank that stood in the yard. I was vexed and drew the obvious moral. 'That's what comes of having a horse standing about doing nothing,' I began. Old Jim began, 'I remember a horse once . . .' But he had lost his audience."

Strange how the old horsemen always seemed to win in the end.

Not all farmers, of course, would allow themselves to be ridden rough-shod by their carters. On the larger farms where a head carter might have several men in his charge, rules were laid down and in the case of Chesterton Farm on the Bathurst Estate in Gloucestershire, they were published :

The Carter will obtain from the Bailiff the weekly allowance of corn and serve out to the driver of each team daily the feeds appointed by the Bailiff. He is to keep the stable granary locked.

The carter and each ploughman on coming home at night to hang up his Harness on the numbers in the Harness house corresponding with those on his boxes, and to clean their horse thoroughly morning and night.

The horses had to be led to water, haltered from April to October and to be supplied in their boxes from September to May.

Each driver of a cart to stop at a gate, prop it open, lead his horse through, and stop on the other side, and close the gate excepting in the case of continuous days hauling through a gate set open for the day.

Even so, the most rigorous rule that a farmer could devise would never deprive the cunning carter of the last laugh. His final revenge was always in the little bottles of lotions, potions, poisons and elixirs and armed with these the carter could perform what would often appear to be magic.

In his record of farming by horse in Essex, Ashley Cooper records a story told to him by "Pod" Martin:

"The farmer told the head horseman to get a pony back from the meadow. No-one else could get near it, and we couldn't do anything with it at all, but the old horseman walked down the lane to the meadow and got out a little bottle, no bigger than a matchbox, and put some of this scent on his handkerchief, and that pony came up to him as docile as a kitten. Of course, being nosey, I wanted to know what he had used. He let me look at the bottle but he wouldn't tell me what it was.

"Another time [he continues] we had an old horse that we had to put a waggon on. You'd think the old thing hadn't got any strength at all, it was so old and knocked up, but this head horseman would

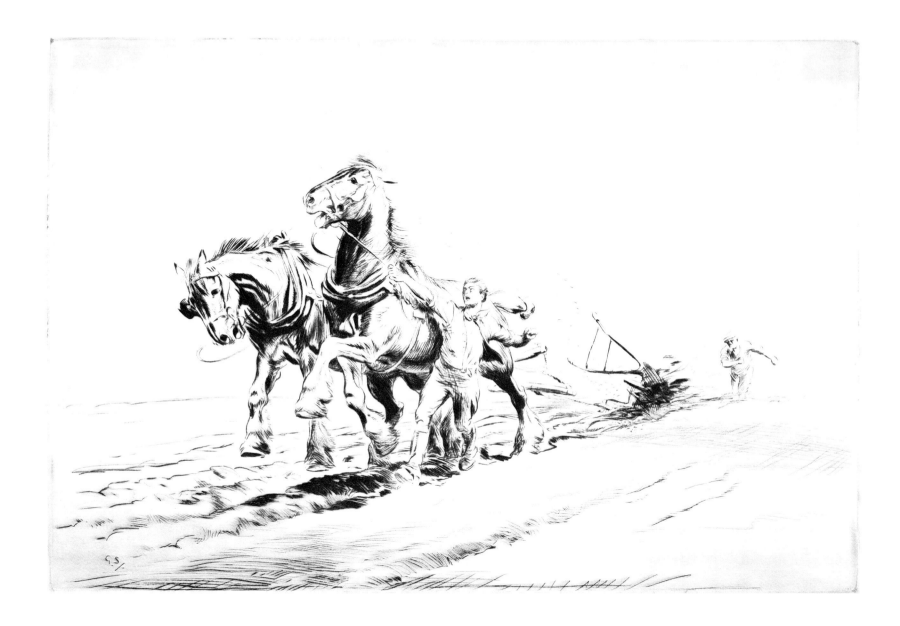

Waspies!

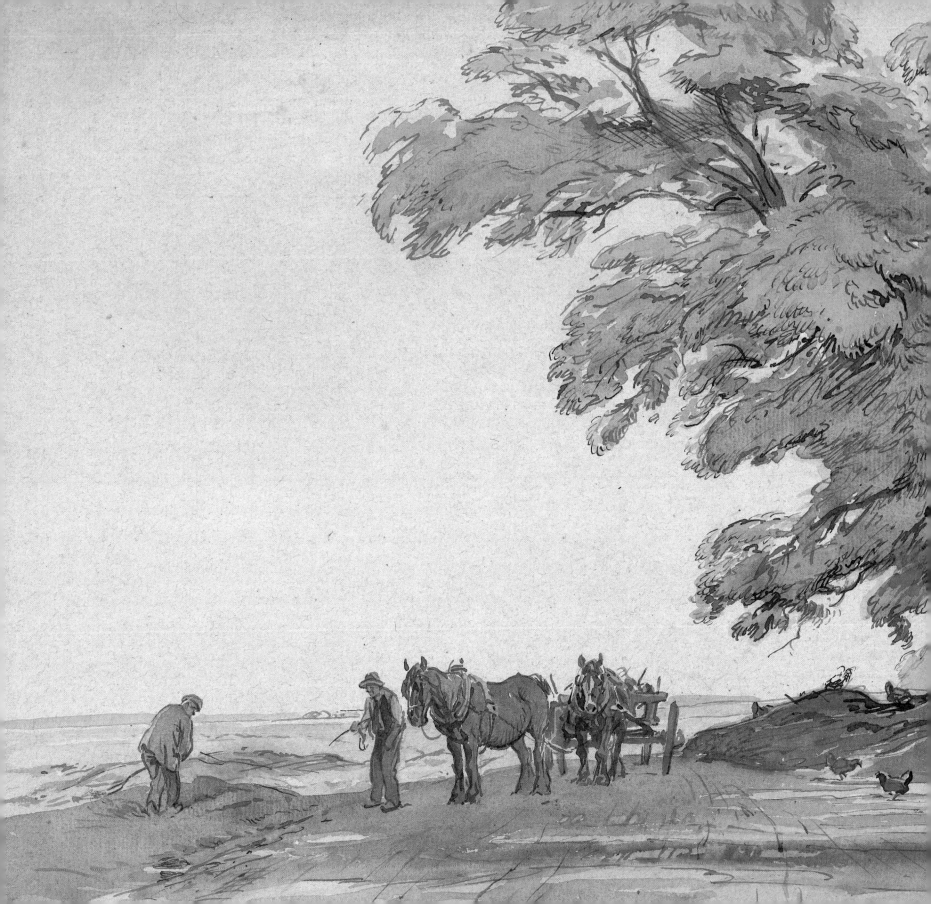

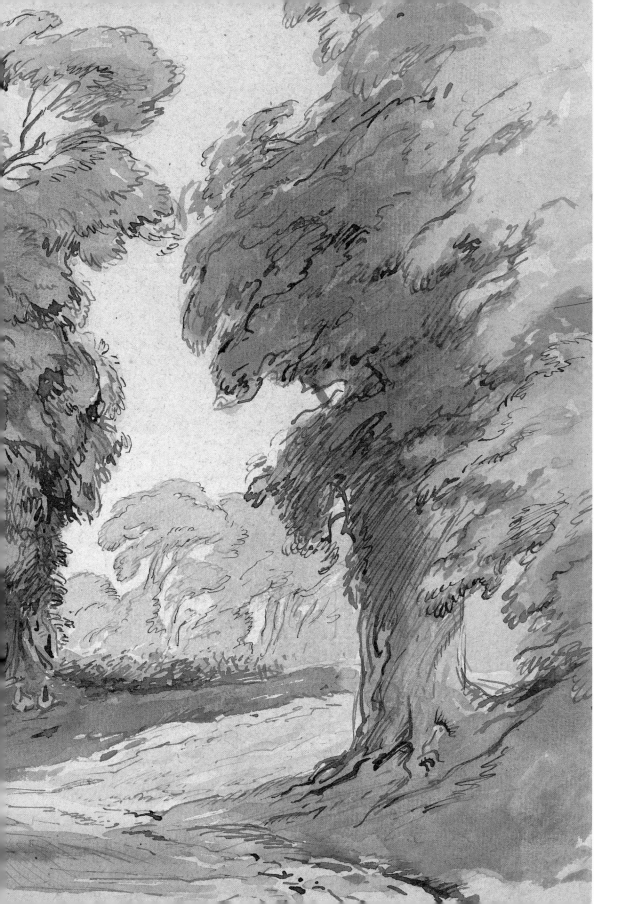

'chemicalise' it up somehow, and for a few hours it would be just like a colt again."

If the recipes for these potions were ever written down, they rarely changed hands. The mastery of the horse was a precious part of the horseman's craft and to share his secrets was to put his job in jeopardy. It is said that secret societies existed, and only by humiliating initiation were young horsemen allowed to enter. Upon becoming part of the Brotherhood they were told what was known as the "horseman's word". It was a word, or phrase, which gave man complete mastery of the horse. To reveal the word to anyone outside the society would mean death. Not surprisingly, there has been much speculation as to what the word might have been, but no one knows for sure.

What is certain is that much mystery surrounded the cart-horse. There was as much belief in superstition as in simple technique and if anything occurred which could not be explained, then it was assumed that some kind of magic must be the explanation. There have been many dramatic examples where the relationship between man and horse appears to have been transcended by some higher influence, and the best of these stories were recorded by George Ewart Evans in his book *The Horse in the Furrow*.

"These 'owd horsemen," one farmer told him, "you couldn't tell 'em anything; and they'd never tell you! I seen one of 'em put a stick up in a field in front of his pair of horses, and they wouldn't budge from where they were for anybody." And another tale:

> "A horseman brought three fine horses into a Suffolk town on market day and stabled them and baited them at an inn. The stableman happened to say to him 'You got three fine horses there, bor.'
>
> " 'Yes,' he say, 'and I know right well how to handle 'em.' Now the stableman wanted to finish early that afternoon, and to do this he needed to move these three horses to a stable in another part of

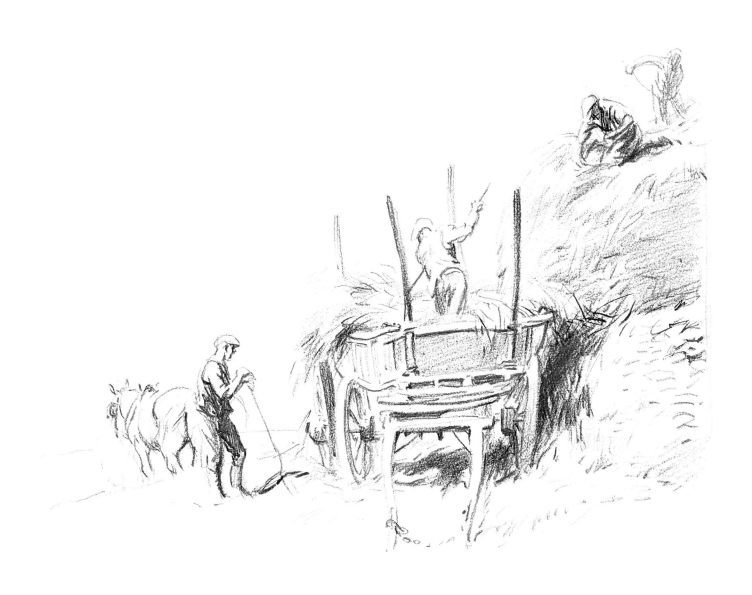

the yard. So after a while they decided to change the horses' stalls. But when they tried, the horses wouldn't move an inch. Then one man who was more in the know than the rest said,

" 'I know the way to shift 'em!'

"And he did. He got a bottle of vinegar; poured some in his hand and smeared the muzzle of each horse with this as he moved him from his stall. The horse couldn't smell nothing else when he did this; and they got 'em all out without any trouble."

Magic ways from magic days.

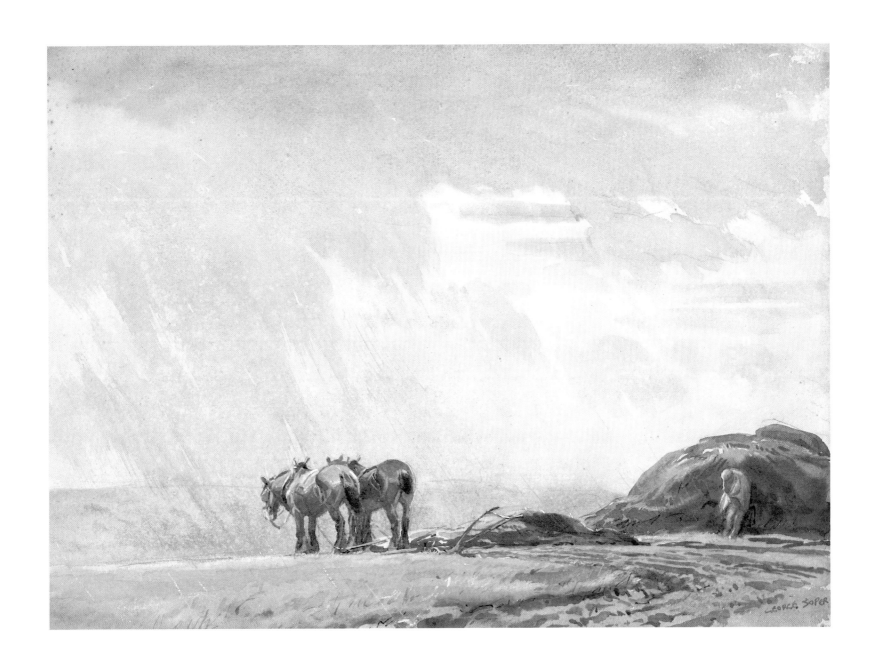

——— 4 ———

PLOUGHING

MEMORIES OF THE golden age of the working horse are becoming dangerously scarce. Few horsemen were men of letters and the knowledge they had acquired was passed by word of mouth. Hardly any wrote books. What literature there is has been written by farmers; one step removed from the "shop-floor". But even if you include the writings of Bob Copper, Hugh Barrett, Adrian Bell and John Stewart-Collis, the volume of literature hardly does justice to the era.

If you assume the horse to have ended its days on the farm in, say, 1945, then men who are now 60 are hardly old enough to have been educated in the traditions of horse-farming. Those who remember even its latter days with real experience must now be approaching their 80s. They are becoming a rare breed.

So, in the tradition of George Ewart Evans, I have recorded a conversation with one of "the few". In the 1950s, Ewart Evans realized that the unwritten inside knowledge that horsemen possessed was fast being lost. From many long conversations over many years he slowly put together a jigsaw of traditional wisdom which culminated in his book *The Horse in the Furrow*. Without it, a huge chasm in our knowledge of the working horse would have existed.

None of those that he spoke to would be alive now and so I had to turn to the last generation of horsemen; the ones who were in at the end and saw the grand, sad finale.

I imagine that both George Ewart Evans and George Soper would have

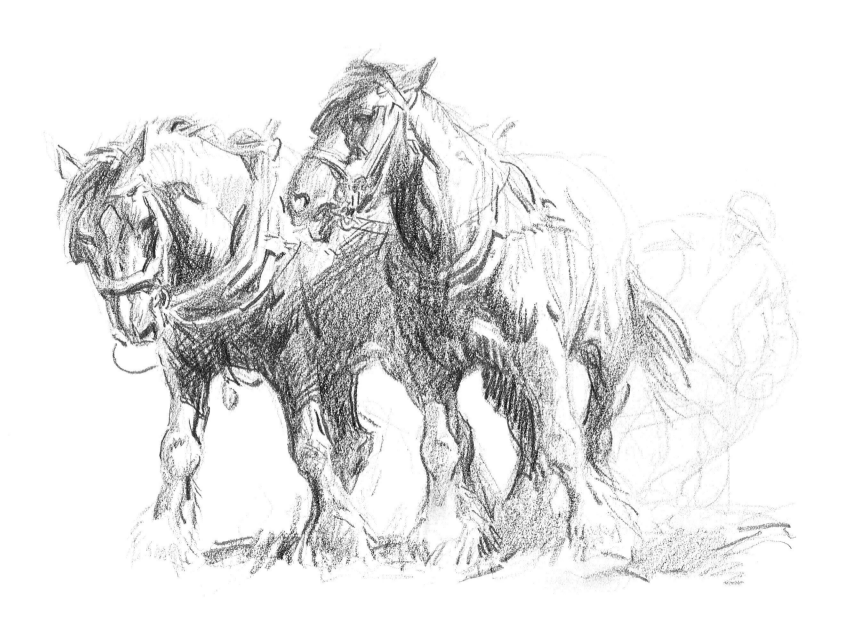

taken to John Randall. Ewart Evans would have found him forthcoming with rich, detailed, unsentimental memory. George Soper would have been drawn to him as the epitome of the landsman: his distinctive gait (described as "like a man who permanently has a sheep between his knees"), his ruddy, weather-worn features telling of long years on wet, windy Downs, would surely have been captured in a Soper drawing.

John Randall has made his name as a shepherd. His name is never far from the top of the prizewinners at the Smithfield and Royal Shows with his Dorset Down sheep. He is a man of great tradition who wears breeches and buskins "for best" and would not be in any way ashamed to walk through the West End of London wearing them, as he has done on several occasions. "I have never shown a sheep or sold a sheep in a pair of trousers," he confided to me, "I wouldn't know how!" These are his memories of his early days as a carter, working horses. As you read them, imagine a man in his 70s who looks as fit as most men in their 40s, and imagine too the twinkle in his eye as he enjoys telling his tale.

"Farms were mechanised round about the middle of the war. I only remembered ever seeing two tractors round here though. As late as the 1960s, you could still see a farmer drive a cob to market.

"Basically, our horses were Shires. Hairy-legged old sods! Then we had what we called 'half-way' horses; they were bred by putting a Shire onto a Welsh Cob. They were sort of miniature Shires, if you like, and they were bred on the bigger farms. It used to be the Show Committee's job to travel a stallion round the farms. These stallions often came from the Midlands or from Yorkshire and they'd be based on the farm and stay there a month till they'd served all the mares. There were lots of dealers in those days, like second-hand car dealers now. You see, there was money in breaking horses then. You got some work out of them while you were breaking them and then you got a fair income when you sold them for town work. In the

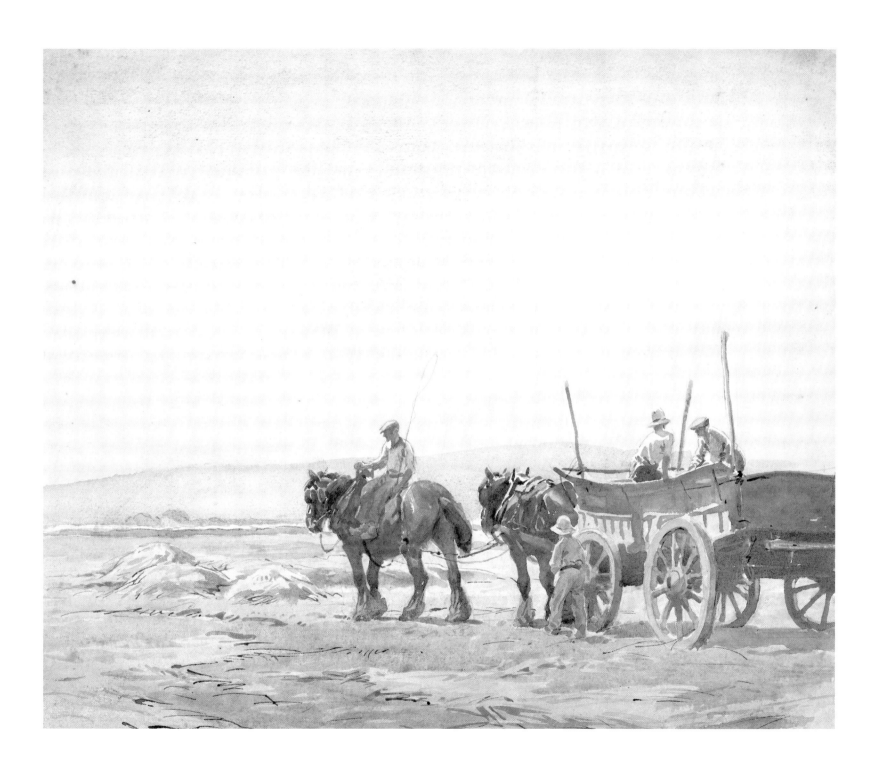

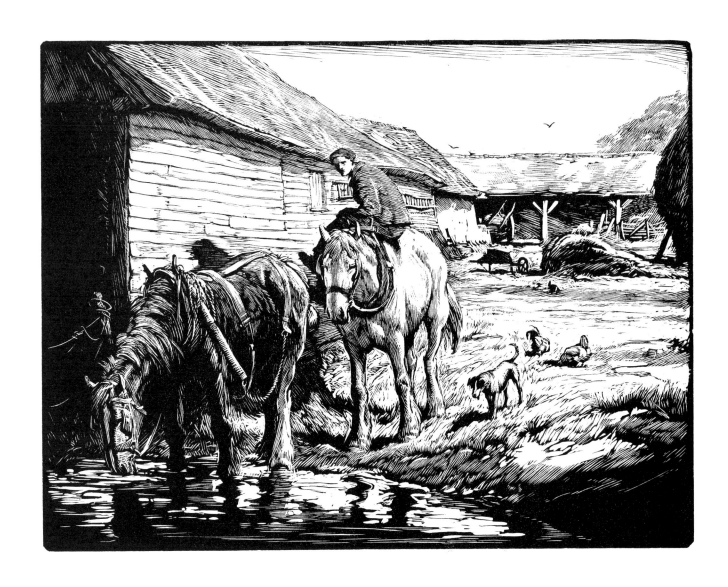

1930s, you could buy a horse for £25 and sell it for £60 three years later.

"Temperament was the most important thing with farm horses. 'Staunch and true in all gears!' was what we used to say. What you didn't want was a bloody thing that ran away. Mind you, some poor sods were treated cruel; not fed and worked hard.

"Boys were put to work with 'caddlers'; older horses, a bit stiff in their joints, and they'd go hauling mangels. The older horses were easier for a boy to learn on and that's how they served their apprenticeship. I left school at 13 and drove three horses by the time I was 16. Nobody 'ud do it today. We were up at five and then the horses would have three feeds before starting work. We'd just give 'em 10 minutes' worth of feed at a time so they didn't rush at it. It was usually oats, chaff and mangels.

"At seven, we'd harness them, leave the stable and we'd have half-an-hour for lunch. Then we'd drive till two, feed the horses and be back in the stable with horses fed and bedded by three-thirty. At six, we went home for our tea, then one of us would pop back to rack-up for the night with hay. We did that six days a week.

"Each team of three horses had $2\frac{1}{4}$ cwt. of oats a week and, I tell you, by Monday morning they were up on their hind legs when they came out of that stable. They had a new set of shoes every quarter and the old shoes were removed and re-fitted every six weeks. If they fell off in-between, you changed blacksmiths bloody quick.

"Ploughing was more or less continuous round the year, certainly from September through to April on the old four course rotation. Now it's all back-end (autumn) work. Here in Dorset, on the chalk-arable, you can get on the land most times of the year. There's now't in ploughing, much. Your horses have to be well trained. It's the setting of the plough that's the thing and the 'striking out' and 'coring-up'. Ploughing up old grass leys was the best job of all but

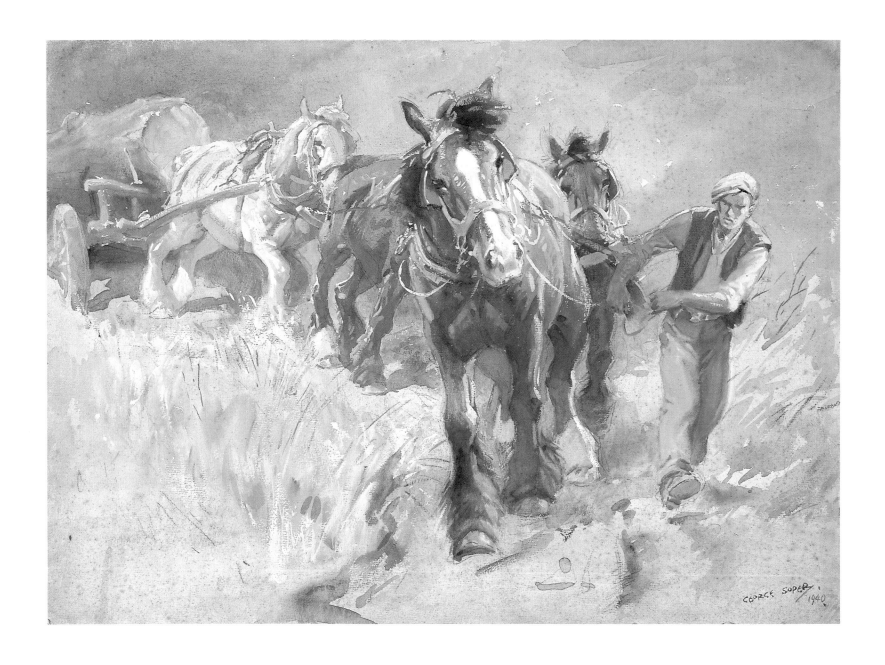

the most difficult. You had to have your skimmer set just right or you'd leave a little bit of grass showing. That was the worst thing you could do. Or ploughing on stony, flinty ground, that was awful.

"Everybody was jealous of their reputation in those days. These days as long as they alter the colour of the soil, they don't care.

"On wet days, when we couldn't plough we used to oil the harness. But it didn't get polished. It would have been polished if you had to take the horses on the road to do a delivery to the mill or railway station. A good carter would have his own set of bells and brasses and you'd get an extra half-crown for doing road work because of the extra work you'd put in getting the horses and harness ready.

"None of our men ever used a whip and God bloody help him if the farmer ever saw him take a whip to a horse. We used to break 'em in at two years old. You'd only do a couple of weeks work with them at that age. You'd put an old, steady horse in the shafts, and the colt in front of him and then another steady horse in front of him. If the young 'un lay down he just got dragged along. But they learnt from the older horses.

"Horses would live 15 to 20 years and a lot of horses that went off to work in the towns came back to finish their time on the land. The best carters thought the world of their horses and it was a poor man who wouldn't be prepared to pinch extra feed for his horses.

"I never did much timber-hauling with horses but father was a wheelwright and the estates always had timber sales. You know, those horses they used for timber-hauling never were driven with reins. Once they started, they would never stop because they knew the effort that would be needed to get started again. Huge lumps of timber they would drag. The horses used to have to get down on their guts and heave. They'd be down on their knees. No, you'd never stop 'em once they'd got going. The timber haulers would have any horses as long as they pulled. They didn't even mind horses

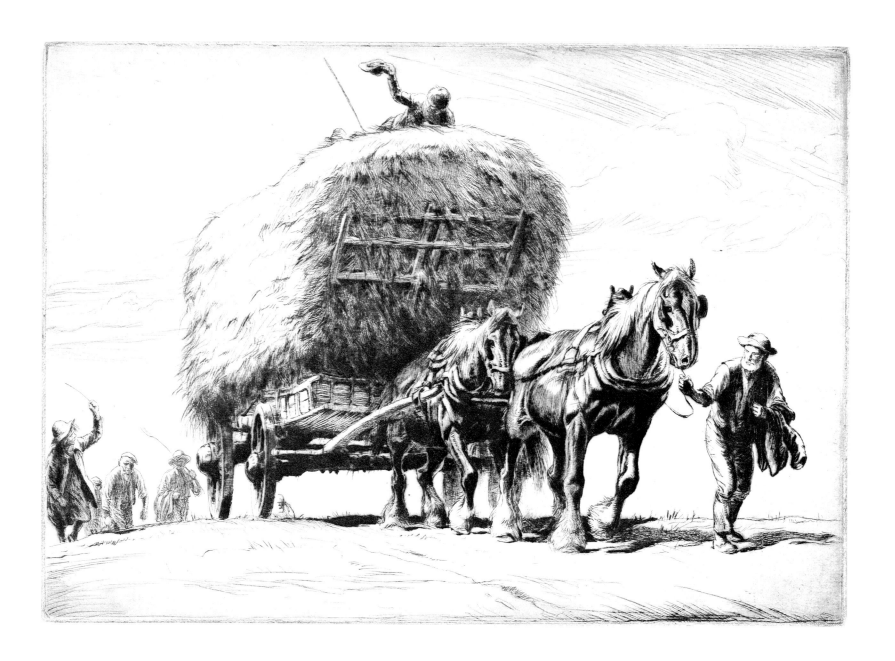

that bolted because they wouldn't get very far and the harness was very strong – three-quarter inch links on the chains. But the horses didn't last long. They always went in the legs and shoulders.

"Harvest always started for us in June when we cut clover. We didn't make silage in those days, clover was our basic winter food. We reckoned we could cut an acre an hour with good horses but it was a lot of hard work. At the end of July, we'd cut oats. We used to cut them a lot earlier than they do now. We cut them just as the milk had gone out of them and the oats were firm and the straw was usually still green. The horses would be three abreast on the binder. Those old binders were horse killers; bad bastards, they were. There was the knife to drive, three canvasses, a packer and knotter and if you had a sheaf carrier you might have eight sheaves on it at any given time. You'd have to change your horses every three or four hours but some used to keep the horses on and going all day, poor sods.

"After harvest, it was time to start ploughing again and looking back on it all, I would say that was the best job. If you haven't ploughed with a team of horses, you haven't lived."

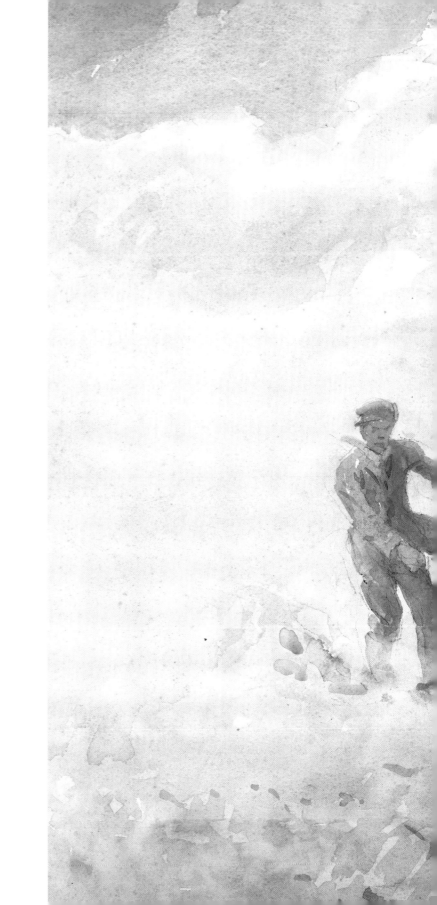

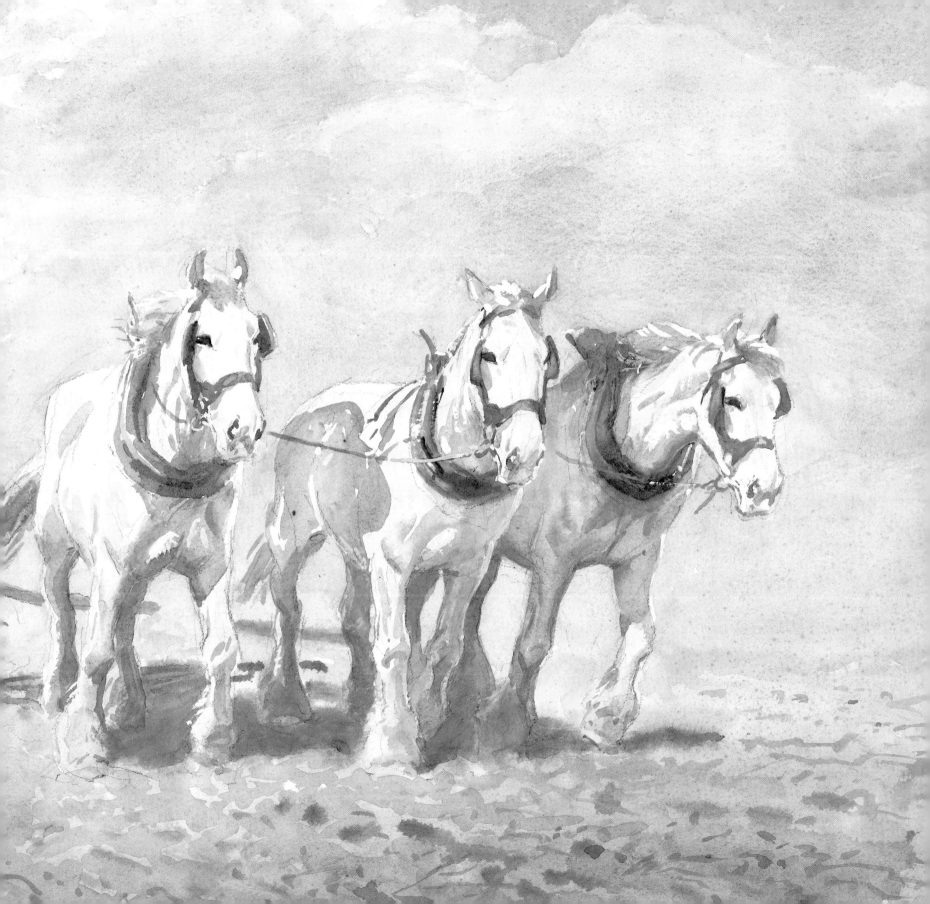

5

HARROW TO HARVEST

IT IS ALWAYS the problem, when hearing reminiscences of old farming days, that the stories throw up more questions than they answer. Why, for example, was it ploughing that a man was proudest of, and why was it so skilled? What was it about ploughing that made the achievement of a straight furrow cause men to swell with pride? And what of all the other farming operations that transformed seed into plant into food into cash? What did the cart-horse actually do to help the farmer realize his living off the land?

To provide answers, I think it best to look at the farming year and the sequence of operations that starts with bare land and finishes with a grand flourish of harvest and merry-making. Everything, in fact, from "We Plough the Fields and Scatter" to "All is Safely Gathered In".

The farming year starts in September, on Michaelmas Day, the 29th of September. It is the day upon which new tenants will take a farm and the day rent becomes due. Hopefully, harvest will have provided sufficient to pay it. Michaelmas was also a time to observe the elements for portents. It was said that "If you eat a goose on Michaelmas Day, For all you buy for a year, you'll have money to pay". As far as weather forecasting was concerned, "So many days old the moon is on Michaelmas Day, So many floods after," or "If the ice is strong enough to bear a man before Michaelmas, it will not bear a goose afterwards". And a final word of advice: "Never eat a blackberry after Michaelmas Day, for the devil spits on them all."

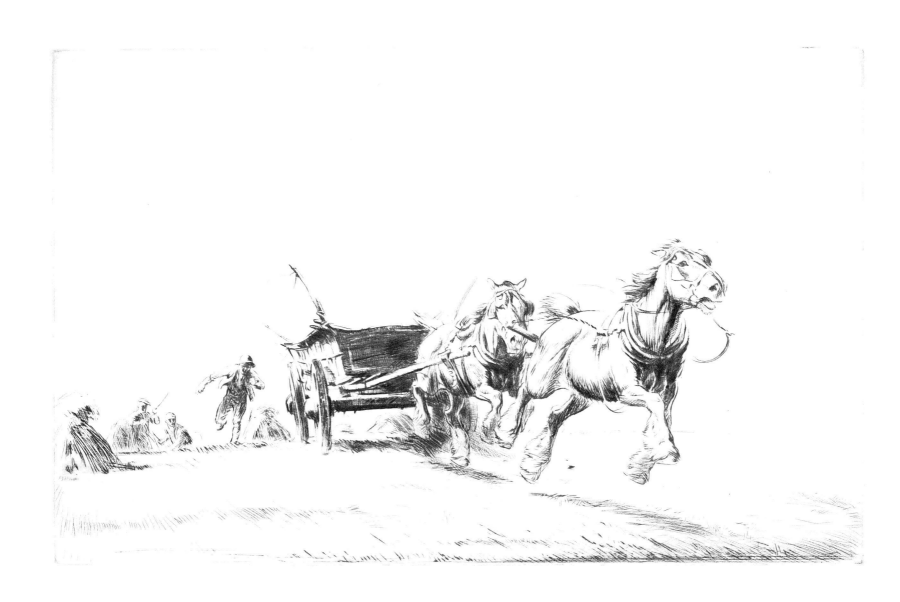

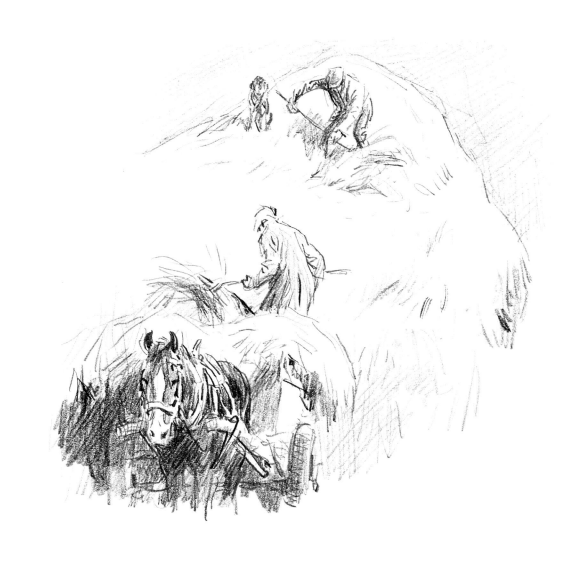

On the farm, a major rearrangement of the landscape would have taken place. Where once stood acres of shimmering, golden corn all that would remain would be dull, spiky stubble waiting to be ploughed deep under and forgotten. For endless days or weeks the horses would have dragged the heavy mechanical binder round the fields, gathering laden stalks of oats, wheat or barley and tying them into sheaves. An army of men with pitchforks would have pitched them high onto a waggon only to have to pitch them again, but even higher, into stacks in the stackyard. By September the stacks stood tall and proud; a measure of a farmer's efficiency and a portent of his prosperity for the coming year. In this era, there would be no more harvests for a twelvemonth.

But preparations for the next one would not be far from the farmer's mind. There might still be a late crop of clover to cut to make into hay for nutritious winter feed, or late potatoes to lift; but the ploughing season was approaching, and attention must be turned to the vital task of turning the soil to make it new again. It was an operation on which a farm's fortunes depended and on which rode the jealously guarded reputations of the men who steered the ploughs across the landscape of England. Make no mistake, even as late as the 1920s and '30s when George Soper was painting and drawing, the ability of a countryman to handle a plough was the benchmark of his worth. A man was as good as the straightness of his furrow, and it was the custom of farmworkers on a Sunday to wander around the lanes inspecting the work of others. No crooked furrow would escape inspection, and its perpetrator would be ridiculed in the pub that night.

The landscape of England has been shaped by the plough. From the earliest days of ploughing with oxen, plots of land were defined as being the area that could be ploughed by one man and his team in a day. In Mediaeval times, units of measurement were built around the area which a team of eight oxen could plough in one year. This was a rather large chunk of land, and so was subdivided into the area that could be done in a day: and this was called an acre. Ploughmen, working with oxen,

carried a stick or a goad with which to drive the oxen forward. This gave the measurement of the "rod": the length of a furrow, or furlong, was usually 40 rods. The problem was that different ploughmen had different rods, varying from 10 to 24 feet, and a standard was eventually arrived at which was $16\frac{1}{2}$ feet or $5\frac{1}{2}$ yards. The school exercise books of the 1950s may have seemed a trifle conservative in steadfastly printing the "tables" of chains, rods, poles and perches; but those of us who still plough land in nine-inch furrows and derive our instructions from elderly books that recommend the sowing of so many pounds of seed to the rod, find them vital in doing the conversion to kilograms per hectare, as directed on the modern metric seed bag.

It is difficult to describe the satisfaction of ploughing with horses. I have used the musical analogy before, and it seems a good one to me. Ploughing is like making music: when the horses, the man and the plough are all in tune it is truly symphonic. It is also true that whilst many of us can take our horses and ploughs and get a recognizable tune out of them, it is only on a few occasions that we can make real music. But following the plough is a deeply stirring occupation, providing great periods of solitude for deep thought, combined with strenuous exertion and inhalation of rich, earthy fresh air. As Ralph Waldo Emerson wrote, "Men do not like hard work, but every man has an exceptional respect for tillage and a feeling that this is the original calling of his race."

That farming literature which does exist from the era of the horse devotes by far its greater part to the beauty, the importance and the technicalities of ploughing. In the first quarter of the last century, Stephens' *Book of the Farm* appeared. It was a definitive work and it is difficult to find a better one for detailed instructions on farm work using horses. On the subject of learning to plough, he had this to say:

"Ploughmen cannot learn their art at a very early age, and every business ought to be taught then to reach a high attainment in it. Ploughing requires a considerable degree of strength even from

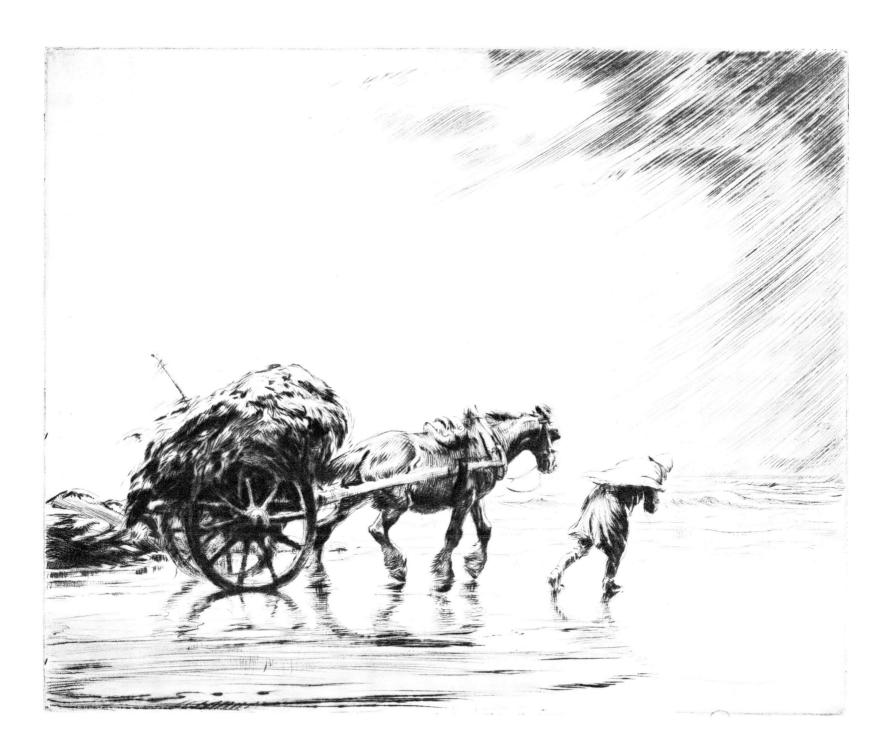

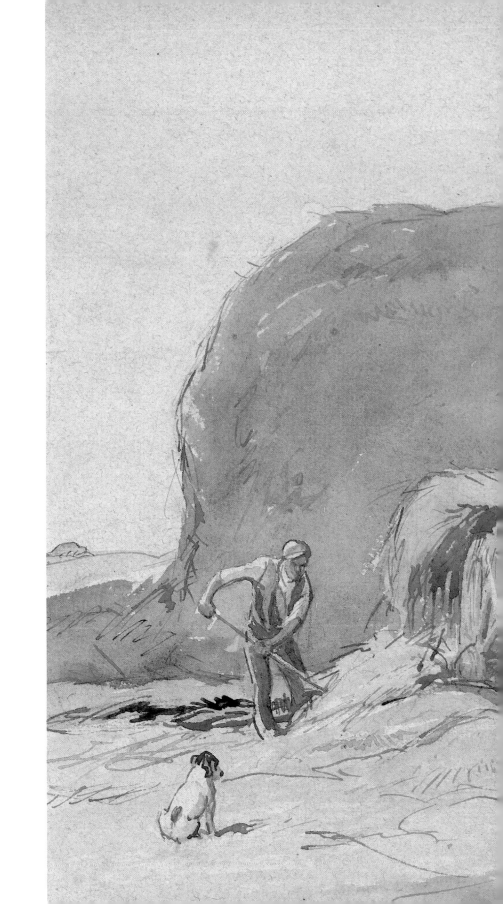

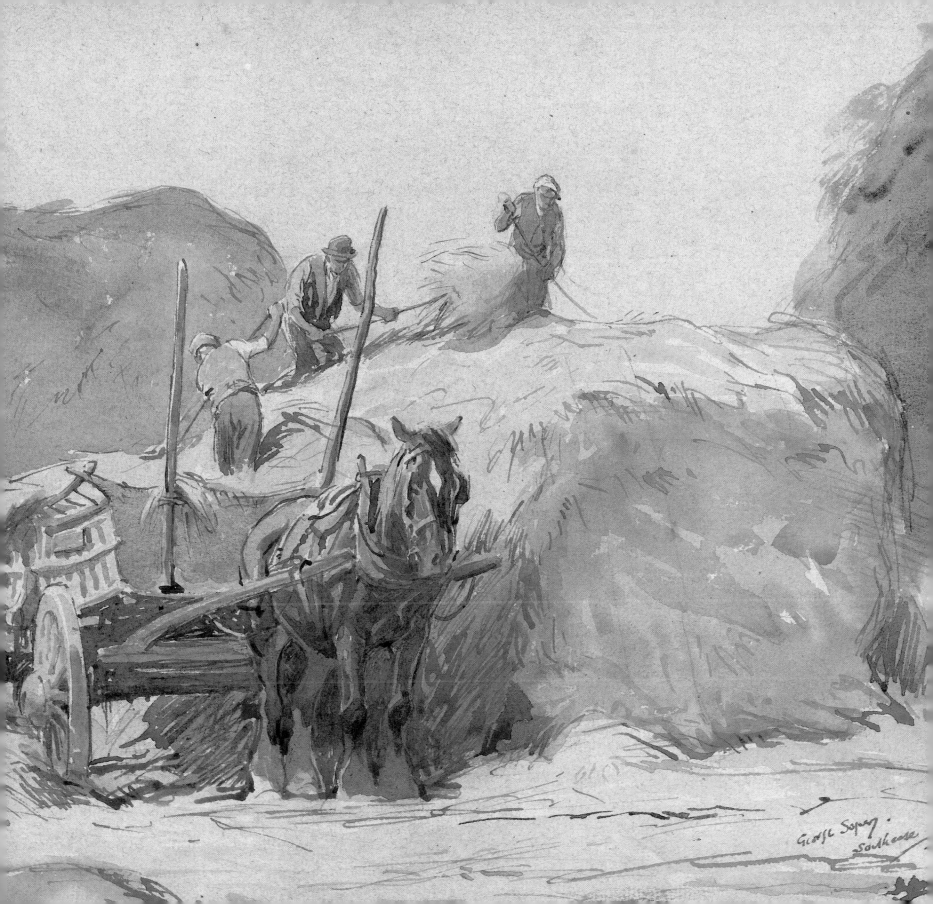

grown-up men, and it bears much harder on the learner; but even after young men have acquired sufficient strength to hold the plough, they are left to learn ploughing more through sheer experience than by tuition from those better acquainted with the art. Experience cannot be transmitted from father to son more in this than in any other art; and in this, as in other arts, improvement is more frequently affected by imitation than by efforts of individual ingenuity and study."

It has to be said that old ploughmen did not make it easy for youngsters to learn. The old boys kept their secrets to themselves; which was understandable, for secrets were all they had. They didn't own the land, the horses or the plough but they had the knowledge to work all three, and it was precious to them. Even today, an old ploughman at an agricultural show or ploughing-match might help a newcomer by adjusting his plough, but he won't tell him what he did, or why he did it. You had, and still have, to look and learn and not expect to be told anything.

Once you had mastery though, you had a position in your small society which commanded respect. Stephens' *Book of the Farm* proclaims:

"Good ploughmanship requires greater faculty of observation than most people would imagine – greater than many young ploughmen possess, – greater judgement than most will take time to exercise, – more patience than most will bestow to become familiarised with every particular, – and greater skill than most can acquire. To be so accomplished, implies the possession of high talent of workmanship."

The agricultural engineers and plough-makers of the 19th century were inventive and prolific. They had a plough for every job, on every soil, in every part of the world. The catalogue of R. Hornsby & Sons Limited of Spittlegate Iron Works, Grantham, lists with pride its "Champion

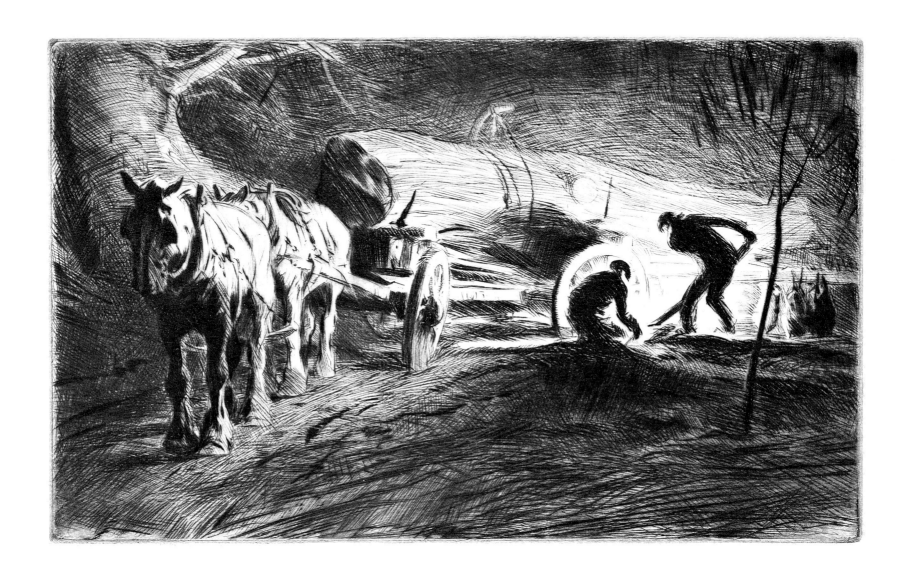

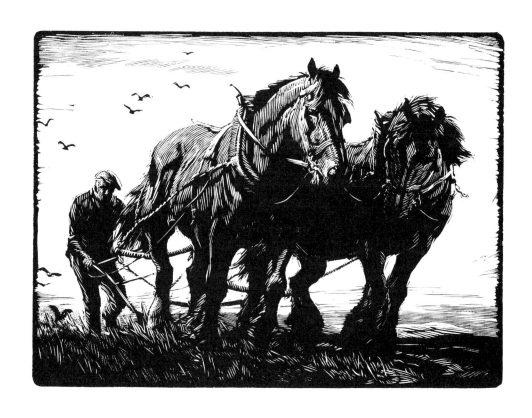

Single-Furrow Plough" or the "Favourite Digging Plough in Ireland," of which it boasts:

> "Ploughing, scarifying and harrowing are the usual methods adopted to prepare land for the reception of seed. All these duties are performed by Hornsby's Digging Ploughs at one operation. They will do similar work to that done by the gardener with his spade; the furrow slice being broken up and thoroughly pulverised. Many practical farmers who LOOK TO RESULTS hold that this class of work will produce the best crop, and to such these ploughs offer the further and great advantage of being lighter in draught than the common plough, thus saving horse flesh, and turning over more ground in a day's work. In other words, MORE WORK WITH LESS POWER."

Hornsbys then go on to praise their "Ploughs for Roumania" or "The Best Plough for the Australian Colonies". A single furrow plough was priced at about £4.

Although hundreds of ploughs were invented and developed, they all worked on the same principle. Though they varied in detail they all carried the same basic working parts which were varied in shape or temper to suit a particular task.

A plough has a body, or beam, to which all the other parts are attached. Along the bottom of the plough will be a slide or a "slod" which will allow the plough to slip easily along the bottom of the furrow. At the very front of the plough will be the attachment that couples the horses to it. It is usually called a "hake" and is adjustable to allow the sideways movement of the plough to be balanced. It is also adjustable in a vertical plane, and this will allow the ploughman to adjust his plough so that it does not try to dive too deeply into the earth. Many of these adjustments were to reduce the draught, or the effort the horses had to make to pull it.

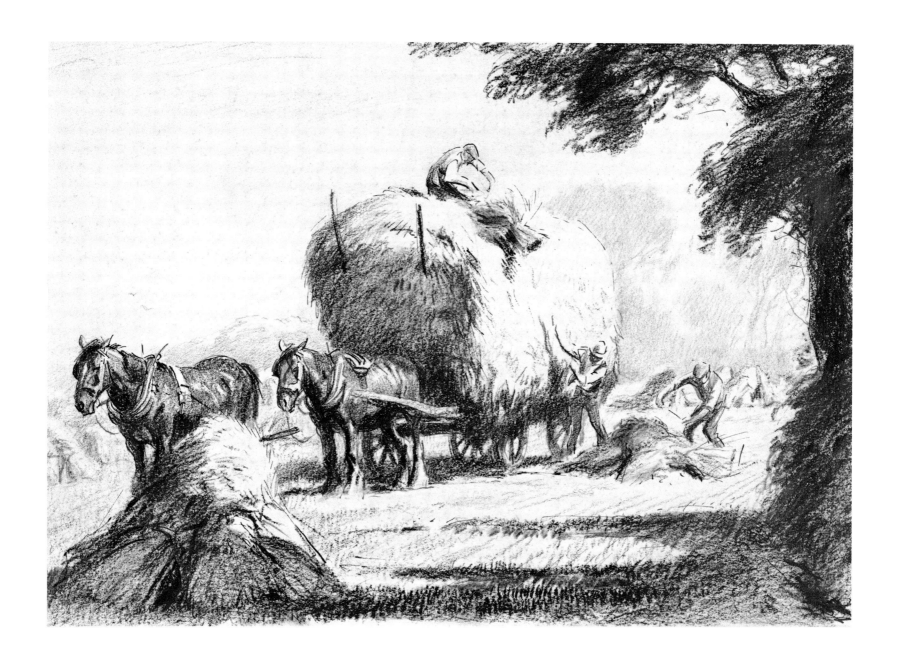

After the hake will come a pair of wheels; one large on the right of the beam looking forwards, and a smaller wheel on the left. The large wheel runs along the edge of the furrow that has just been cut and adjustment of this wheel can vary the width of the furrow. The smaller wheel, which runs on the unploughed land, determines the depth to which the plough works.

Then comes the skimmer, which itself looks like a miniature plough. This is adjusted to run lightly over the surface of the soil that is about to be turned over and scrape off any weed or stubble and drop it into the furrow so that when the whole of the soil is turned, the rubbish is buried.

Then comes the plough proper, which consists of the coulter or knife, and the ploughshare and mouldboard, or breast. The coulter is simply a vertical knife that cuts through the soil as the plough moves through it; the ploughshare is, in effect, a horizontal knife and the action of the two together is to cut a rectangular slab of earth as they move forward. This slab of earth then rides up the curved mouldboard and is inverted by the shape of it. As it topples over, it falls against the previous furrow and leaves no trace of unploughed earth behind it. It is a simple and ingenious process, which is better viewed than described.

To the untrained eye, a ploughed field is a ploughed field is a ploughed field; but to a ploughman there is as much difference between a field of good straight furrows and bad as a cloth-merchant would make between a first-class sample of corduroy and an indifferent one. To read the description of good ploughing in Henry Stephens' *Book of the Farm* is to appreciate how horsemanship and art meet when a man takes his team of horses to plough.

"Correct ploughing possesses these characteristics: The furrow slices should be quite straight; for a ploughman that cannot hold a straight furrow is unworthy of the name. They should be quite

parallel as well as straight, which shows that they are of uniform thickness; for thick and thin slices lying upon one another present irregularly parallel and horizontal lines. They should be of the same height, which shows they have been cut of the same breadth; for slices of different breadths, laid together at whatever angle, present unequal vertical lines. They should present to the eye a similar form of crest and equal surface; because, where one furrow slice exhibits a narrower surface than it should have, it has been covered with a broader slice than it should be; and where it displays a broader surface than it should have, it is so exposed by a narrower slice than it should be. They should have their back and their face parallel; and to discover this property after the land has been ploughed requires minute examination. They should lie easily upon each other, not pressed hard together.

"The ground, on being ploughed, should feel equally firm under the foot at all places, for slices in a more upright position than they should be not only feel hard and unsteady, but will allow the seed-corn to fall between them and become buried. When too flat, they yield considerably to the pressure of the foot; and they cover each other too much, affording insufficient mould for the seed.

"From a consideration of these particulars, it is obvious that ploughing land correctly is an art which requires a skilled hand and correct eye, both of which are much interfered with in the management of the horses. Hence a ploughman who has not his horses under strict command cannot be a good hand."

It all adds up to a great burden weighing on the shoulders of the humble ploughman as he trudges the furrow long. In truth, not all ploughing will be up to the high standards demanded by Henry Stephens, and in many of Soper's ploughing paintings, it is clear that true straightness of furrow has not always been achieved. Soper was nothing if not honest in his portrayal of farming life.

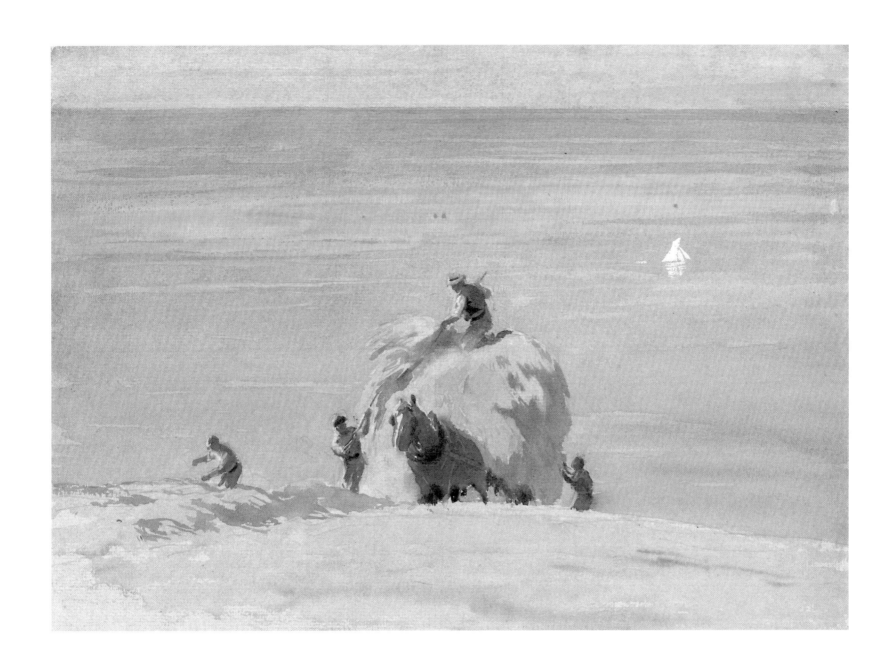

Nothing has been said of the horse so far, but without the remarkable talents of the cart-horse for walking unaided in a straight line, ploughing would be virtually impossible. It is an understatement that "a good cart-horse needs no driving." In fact, a cart-horse that needs driving at all is a liability.

Once the first furrow has been drawn, the furrow horse will walk in it. As long as he can see it he will follow it, one suspects to the end of the earth. At the end of the furrow when he has to turn, then a little aid with the rein for the first couple of times will imprint it on his mind and after that he will do the work for you. The problem comes when you then change the pattern of your ploughing after, say, a couple of hours. You then have a few uneasy furrows while the horse learns his new job.

To plough an acre, which a good man and horses should be able to do in a day, requires man and horses to walk no less than 11 miles. It is no wonder that old horsemen, walking bent to the plough-handles, were crippled young and often unable to work much past their fifties. But cart-horses will plod on till they are 20 or so, many of them doing an average of seven or eight miles a day on rough, cloddy land where every footfall is a potential stumble. The Agricultural Notebook of 1922 gives the facts and figures of ploughing:

> "Length of Furrow – 250 yds. long is the best average suited to the strength of the horses. A furlong was originally a 'furrow long' – 220 yds.
>
> Speed of Horses – $1\frac{1}{2}$ to 2 miles per hour while on the plough.
>
> Distance travelled per acre – 99 divided by width of furrow = miles per acre.
>
> Average time to turn $\frac{3}{4}$ of a minute.
>
> Time lost in turning: For three hundred yards length of furrow, the loss is 1 hr. 30 min. every 10 hours. And to these must be added the times in resting.

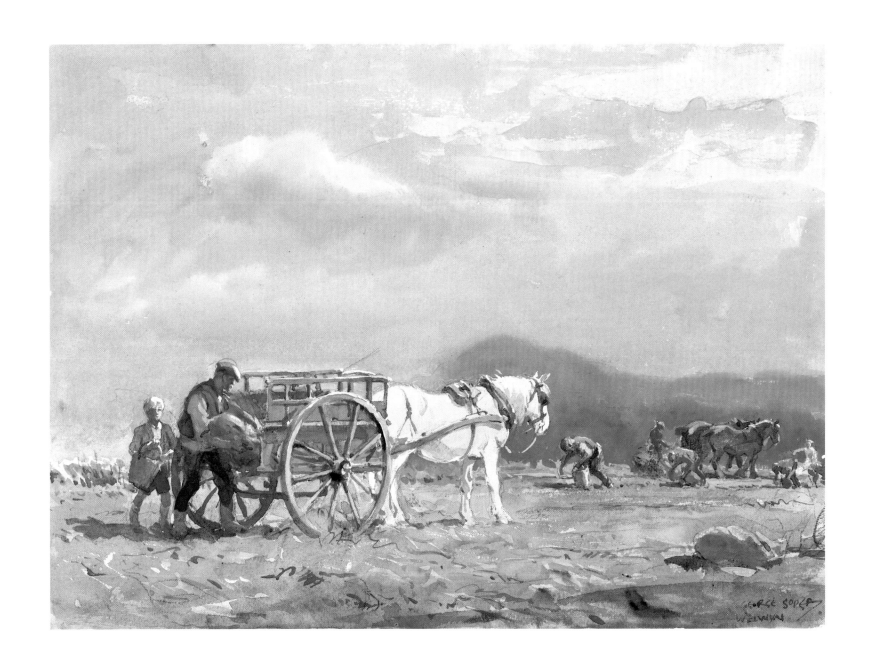

Limit of Draught – 6 cwt. per furrow. Ordinary ploughing varies from 3 to 5 cwt. or from 168 to 280 lbs. per horse or from 30 to 100 lbs. for every inch of depth with slice 9 to 10 inches wide."

As if the daily autumnal grind of turning the soil was insufficient to slake their thirsts for ploughing, September and October was the season of the horsemen's great ploughing matches. These were contests with judges even harsher than those Sunday afternoon gangs of wandering critics. They were grand occasions, the nearest a village would come to being a venue for a Grand Prix. As far as can be gathered, they were democratic affairs where all who could plough were welcome. The records of Collingham Farmers' Club show that a ploughing match was held on the 1st of November 1850 and apart from classes for best plough-man, best pair of horses and best two-year old, there were classes for "The Labourer in husbandry, who shall have brought up the biggest family without parochial relief" and "The Labourer not keeping a cow who shall show the best pig (said pig to have been his property at least three months)".

But the atmosphere of keen contest and camaraderie was captured by North-country farm labourer Fred Kitchen in his *Life on the Land*:

> "Fallowby Fosse ploughing match was held this year on Butter-griggs land. There were about twenty entries for ploughing. Bill Robin took first, and Bob Spink second in the Champion class. It was a fine sight to see the long stretch of teams at work, for the fields were fairly level, and in the main field about a dozen of them stood ready for the start.
>
> "There was a slight fog in the early morning, which caused some doubts as to whether the match could be held, but by the time every one had taken their places, the fog lifted and the sun shone clear across the field. The wad-sticks were set up so true and straight that the ploughmen looking at them, could only see the first stick. The

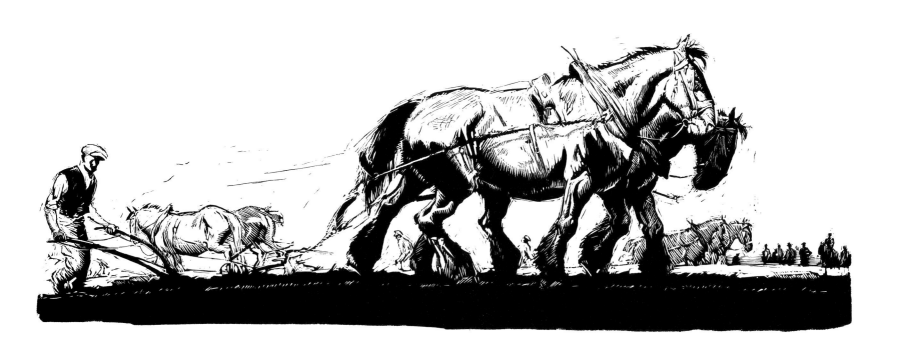

thin line across the field was like a straight-pulled ribbon, where every horse stepped carefully forward, as though mindful of the importance of that first seam.

"The ploughmen, bending low over the plough-stilts, looking anxious until the rig was set. Their eyes fixed on the wad-sticks, they spoke very gently to their teams: 'Steady, Bonnie . . . arve . . . arve . . . arve . . . gee a bit . . . steady!' The lookers by passed from rig to rig, comparing the chances of their favourites. There was a large gathering of farmers present, mostly wearing breeches and leggings. Every one was shaking hands with every one else amid shrewd comments on ploughing, plough horses, and the ploughmen.

"After the ploughs made a start, most of the crowd wandered off to watch the hedge-laying competition and the ploughmen got to work on a clear field.

"Bill had taken Short and Bonnie, as being the handiest pair to manage on this important occasion. Bob Spink had his usual pair of dark browns, Star and Diamond, and very handsome they looked as they walked in perfect step across the field . . .

". . . and tonight in the long room at the 'Ring O'Bells' the farmers and farm men gathered around the tables to eat rabbit pie, roast chicken, roast pork, and vegetables, and listen to the speeches that accompanied the prize-giving. The Member for our constituency was invited to present the prizes. Being a city man, he said he had some doubts about what a ploughmen's gathering would be like. He had rather expected to see a room full of slouching, lop-shouldered labourers. But there was no condescension on his part as he shook hands with these straight-limbed, clear-skinned, intelligent plough lads. Bill Robin was the only one who had a slight roll in his walk; and that was due to his barrel-like shape – and his dinner . . . Bob Spink led the way by singing 'The Ploughman's Song' and everyone joined in the chorus:

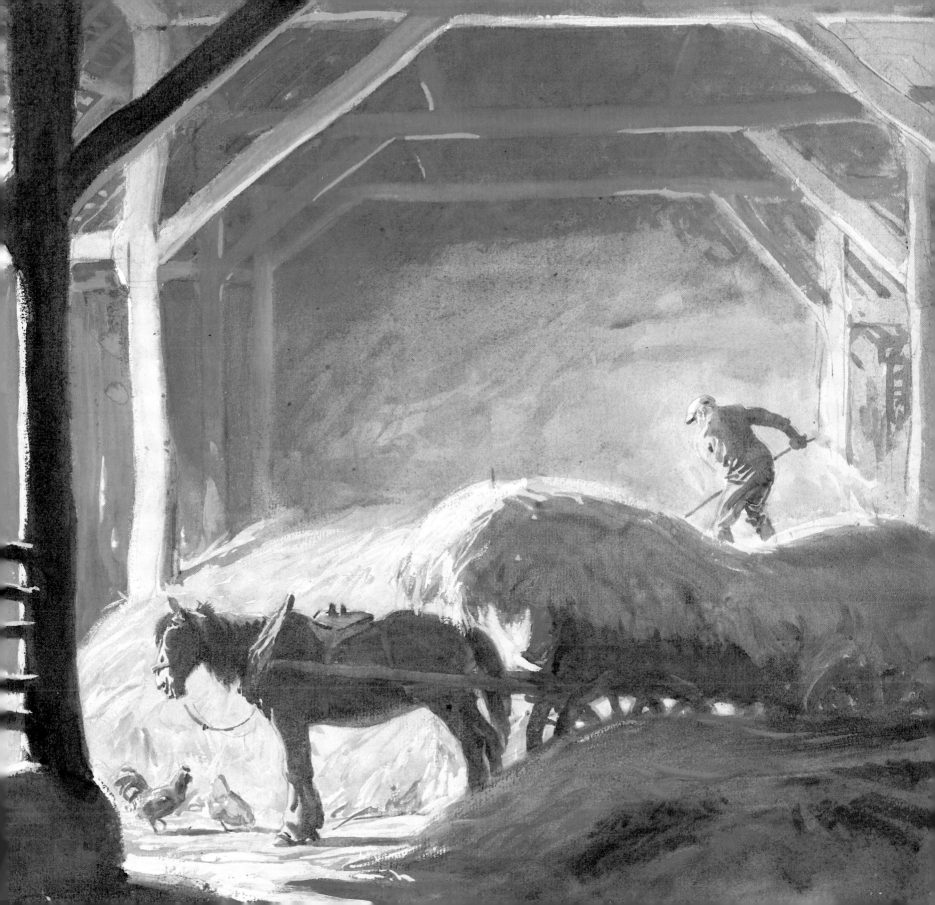

Take no thought for the icy wind a-blowin'
Have no care though the weather starts a-snowin',
Whistle to your horses, lads, and keep 'em gently goin'
Up and down and round about, soon it's time for sowin'
Singing ho ho ho and away gee-ho!

With a clean cut furrow all along,
Whoa-gee-ho, merrily on we go,
Let life pass along with a song all among
The fieldfares, starlings, all the tuneful throng,
Pewit, woodgie, daw, and crow,
Joining in the choir one hundred strong,
Singing ho, ho, ho and away gee-ho!

With Bonnie in the furrow, and Blossom in the line,
We are jolly plough boys, be it wet or fine.
Whistle to your horses till the sun begins to shine,
Waking up the hawthorn and the wild woodbine.

Singing ho, ho, ho and away gee-ho!
With a clean cut furrow all along,
Whoooa-gee-ho, merrily on we go,
Let life pass along with a song all among
The fieldfares, starlings, all the tuneful throng,
Pewit, woodgie, daw and crow,
Joining in the choir, one hundred strong,
Singing ho, ho, ho, and away gee-ho!

Take no thought for the icy winds a-blowin'
Whistle to your plough-team, and sing to the sowin'
Soon we'll drain a beaker when the corn's a-mowin',
Rememb'ring the wide world depends on what we're growin'.

Elevated thoughts. But when Ashley Cooper, author of *The Long Furrow*,

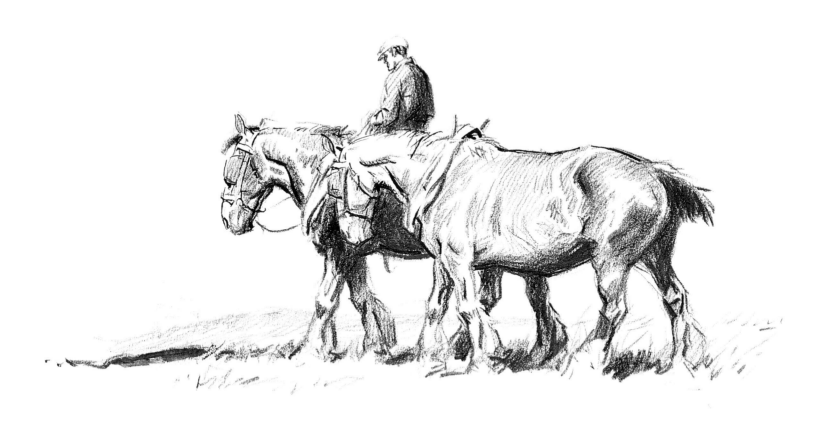

asked an old ploughman what he thought of during those long hours, he didn't get the sort of reply he expected:

> " 'What the hell does any young man think about in a damn great field when he's all by himself for days on end!' he roared back with a vast grin on his face and a wink in his twinkling eyes."

The ploughs would be frantically at work in November and December, in the hope that all the land would be turned by Christmas. If the farm was on heavy, sticky, clay land even Christmas might be too late, for the ground could be too sodden and puddingy to plough. Of course, if such land was not ploughed by Christmas, in a wet winter there was a good chance that it might never get ploughed in time for the sowing of the seed the following spring, if that happened to be wet as well. It was a tradition that ploughmen would sleep with the shiny breast of the plough beneath their beds on Christmas Eve, and it was no doubt their wish that they wouldn't be needing to take it out in the New Year.

In fact ploughing, like most things in farming, never went to plan and the teams toiled in all weathers. On the farms on the lighter, sandier lands there was less urgency, for here the soil drained easily and rain only served to make the land more workable.

The greatest need in autumn was to turn the land that was to be sown that season with winter wheat or barley. Here the seed bed had to be prepared by the end of September if the seed was to sprout sufficiently to withstand the winter, and the land not become too sodden for the horses to work.

So, as soon as the ploughs were rested, the horses were hitched to the harrows to break the clods of earth into finer particles. The simplest form of harrow used to be a bundle of twigs or a bush that was simply dragged across the land. It was not very effective and certainly not as efficient as a harrow made out of iron, but it served to stir the surface of the soil. After

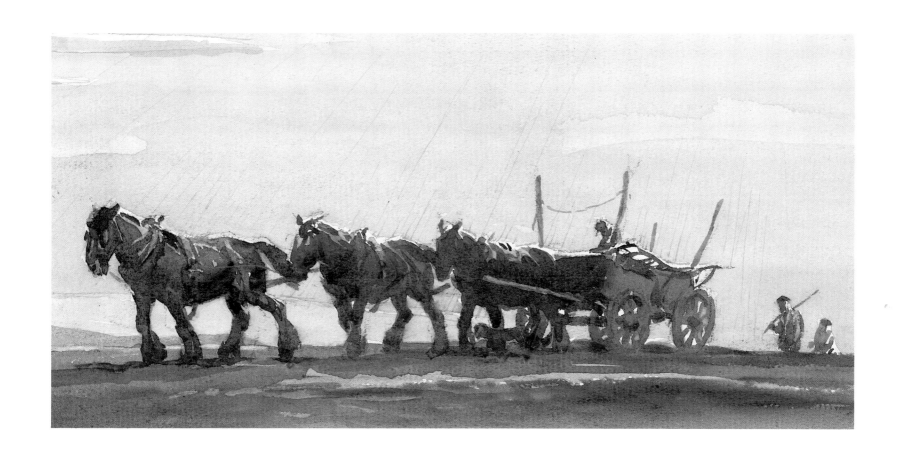

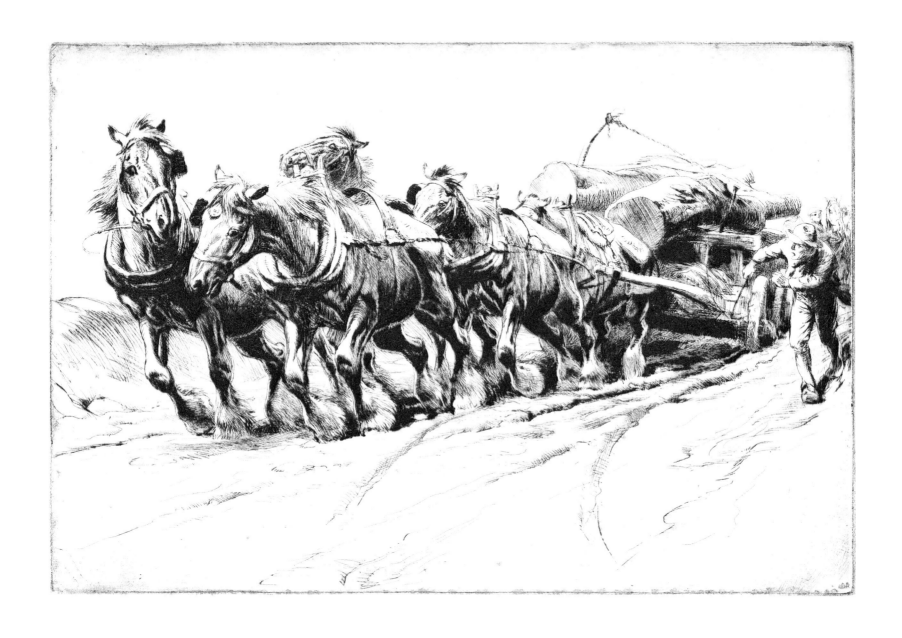

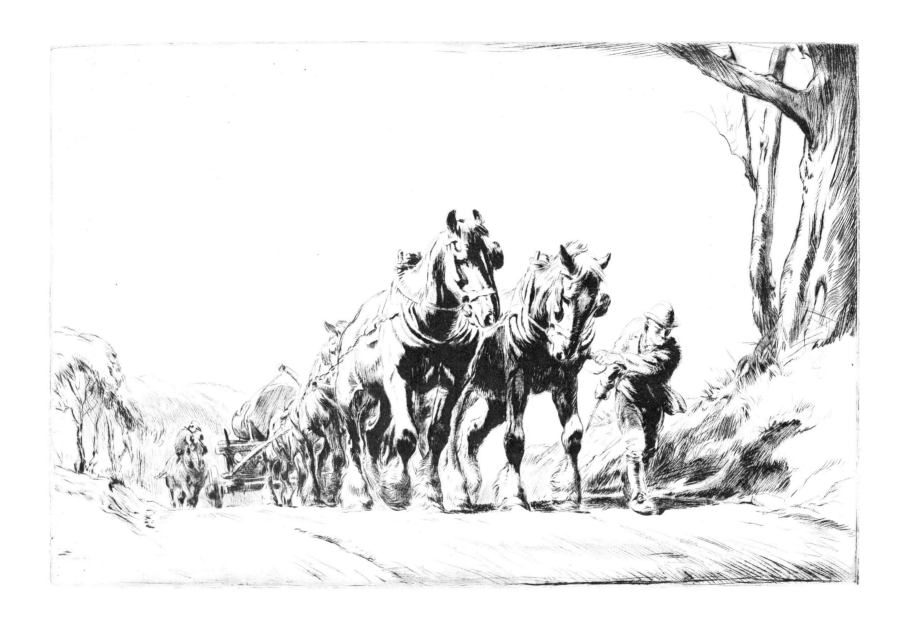

the bush harrow came the wooden harrow which was simply a square frame with vertical stakes fastened through it in a chequerboard pattern. Modern harrows are no different and the design has hardly changed from those shown in the Luttrell Psalter, but the wooden frame has been replaced by iron and the sharpness of the honed points makes the whole thing much more efficient.

There appears to be no great skill in harrowing. It is simply a question of driving the horses up and down the fields with the harrows behind them, first one way and then the other, till the clods submit to the destructive will of the harrows. Thomas Hardy wrote:

> Only a man harrowing clods
> In a slow silent walk
> With an old horse that stumbles and nods
> Half asleep as they stalk.
>
> Only thin smoke without flame
> From the heaps of couch-grass;
> Yet this will go onward the same
> Though Dynasties pass.

Hardly the sort of verse, one might think, with which to take passionate issue. However, two distinguished writers have done so. One was Adrian Bell, a Suffolk farmer and compiler of *Times* crosswords who wrote of his farming experiences in the 1930s and '40s; the other John Stewart Collis who recorded his farming apprenticeship. Of harrowing, Collis wrote:

> "Only a man harrowing clods . . . Like many others I had read and loved that famous poem by Thomas Hardy called 'In Time of "The Breaking of Nations" '. To me just a picture in the mind, no knowledge of what harrowing entailed. Now actualized and made

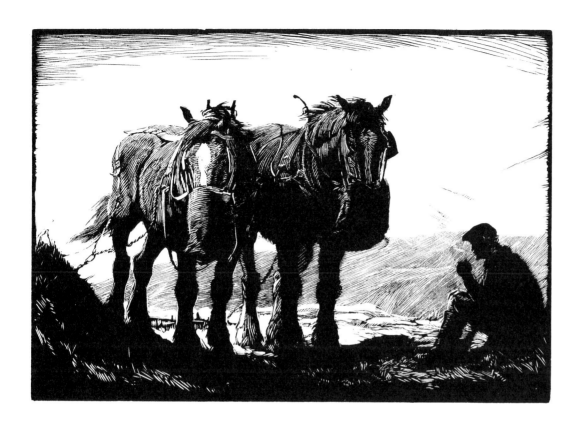

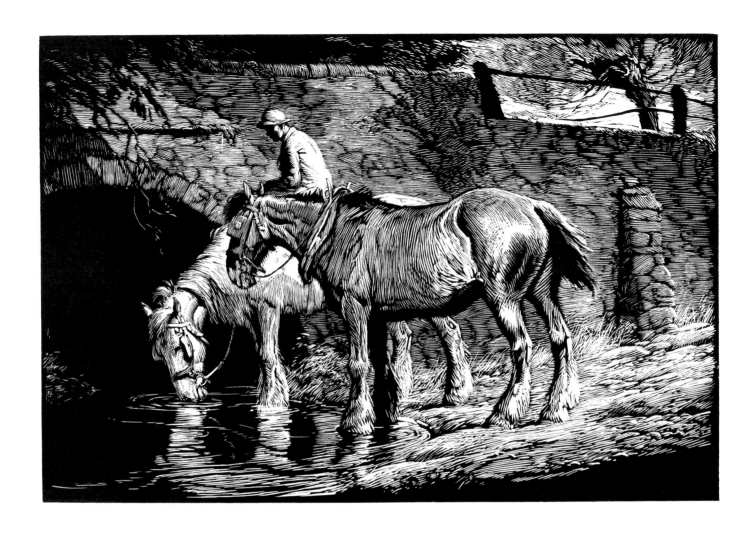

an absolute reality for me – my own job. And does the poem gain thereby? Mr Adrian Bell tells us that he had only been harrowing for a very short time before he began to find fault with the poem. *Only* a ploughman harrowing; that seemed to him all wrong (that deadly realm of 'only') while 'half asleep as they stalk' seemed absurd. I find it difficult to say anything against Hardy (except with regard to Tess) but though the message of the poem perhaps requires that 'only', there seems to me now no excuse for the 'half-asleep'. From the road a number of agricultural jobs look remarkably quiet, serene, slow and easy; but if you stand beside the man in question you may find that he is putting out all his strength, is moving quite fast, and is in anything but a serene state of mind. So with harrowing. I didn't find anything sleepy or serene about it. Not only is it impossible to walk with ease behind the harrow, since you are stumbling the whole time over clods, but you can't see your work properly. You try to go straight across the field exactly beside your previous line, but you cannot see it without close inspection, and even when you do see it the horse is always standing you away from it, and in checking this you come back too much. Consequently you have the uncomfortable feeling most of the time that you are going over ground already done or are missing out considerable areas. In short, it is exasperating. Certainly not something you can do asleep."

Horse work continued throughout the winter, for when the land was too wet to plough or harrow, there was always carting work to be done. Hay and straw from stacks would have to be taken to sheep and cattle which would have been bedded-down in stockyards for the winter. The heavy drudge of muck-carting would fill the odd hours as the precious fertiliser was forked from the yards where stock had trodden and mashed it, into a cart which the horse would then pull to the fields.

And when spring arrived, it would be time to sow the seed for the

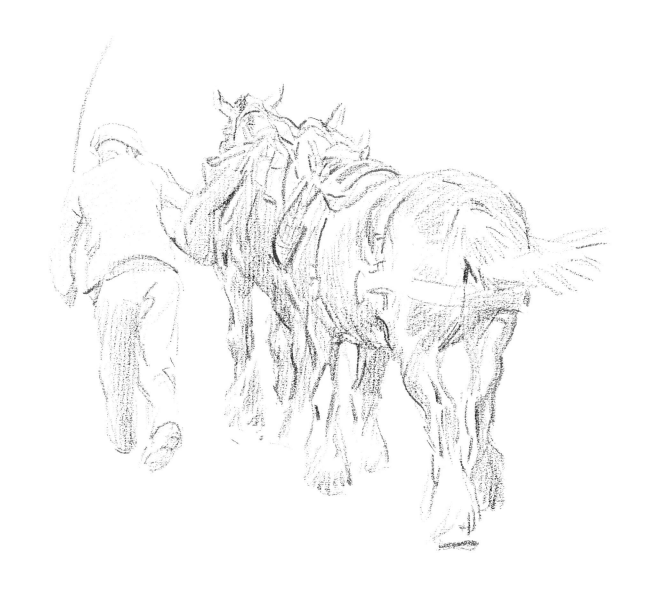

following harvest. The precise moment for sowing called for fine judgement, for seed that was dropped into land that was too wet and cold would sit and rot. However, it didn't do to delay or there might be a reduced harvest. The old way, it is said, to test the land was to drop the trousers and sit on the earth. If it was too cold or damp for the farmer's bottom, it was too cold and damp for the seed.

In his *Book of Husbandry*, John Fitzherbert proclaimed:

> "Go upon the lande that is plowed, and if it synge or crye or make any noyse under thy fete, then it is to wete to sow. And if it make no noyse and wyll beare thy horses, thanne sowe in the name of God."

Drilling corn called for good steady horses, for the machine that deposited the seed in the ground did so in regular lines and if the horses were poor walkers or the man driving did not have complete mastery, when the seed sprouted his drunken, rolling way would be clear for all to see. Pride apart, seed had to be drilled in straight rows simply because, later in the season, horses were going to have to drag hoes between the growing rows to remove the weeds and if the rows were not straight in the first place it would be impossible to hoe without damaging the standing crop. George Sadler, a Cambridgeshire farmer, remembered his early days behind the seed-drill:

> "When I first started drilling I was more or less a drill boy because I was only seventeen. I had to go and lead the two front horses on. We used to have one in the shafts in those days. I don't think it was a Smyth drill but I know one day we were drilling some winter barley and I'd been leading the horses; and it was close and the sweat was running off them. Well, my father came down and he said to the drill man,
>
> " 'Where's that boy, George?'
>
> "The drill man said, 'Look between those hosses!'

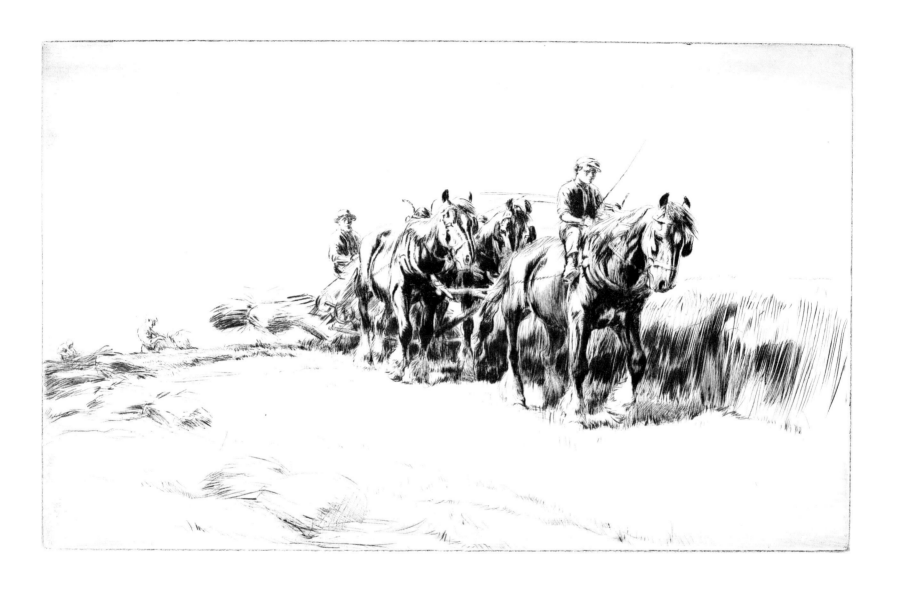

"There was so much steam coming from them horses he couldn't see anything of me.

"We used to drill ten acres a day. And you had to drill it – to the inch! No one must be able to find fault with it; and when it was done you couldn't see a quarter of an inch out. It had to be done right. They took some pride in their work in those days. They were really interested in it; and the old horsemen would go to the pubs on a Saturday night, and they'd call out to someone:

" 'I bet my bit o'drawin' (ploughing) is better'n yours,' or if you were a young lad just started ploughing they'd say:

" 'Well, you made a darn good job of it for the first time. But you got one or two handshakes in it. But never mind, you'll be a better man the next time.' "

The farming year is a succession of anxious moments. The farmer will be waiting for the right weather to drill his corn, and when that is safely done he will be thinking of making his hay. After that he will pray for fine weather for his harvest. For the horses, there are two major exertions before their farming year is over. First, they will have to mow the grass to make the hay. A hot job, but a pleasant enough one – and easy work compared with the pulling of the heavy binder through the corn fields. Binders were known as the "horse-killers" for they required of the horse as much as it could give, and often under the baking heat of the August sun.

A binder is a machine that cuts the standing corn, ties it into sheaves and deposits them neatly on the ground. The sheaves are then set up against each other to dry and then carted, by horse, and built into corn stacks.

The principle of the operation is quite simple but requires a huge complexity of moving cogs, chains and gears to effect the cutting, turning, bundling, tying and ejecting which are all part of the binder's operation. All the power to do these tasks had to be transmitted from the horses, via

a groundwheel, to the mechanics of the machine. This made for heavy work and three or four hours was as long as a good farmer would allow his horses to labour.

Once all was safely gathered in, the workers could turn their minds to celebrations and harvest suppers and the horses, back in the yards now for the coming winter, would feel the cooling air and sense, perhaps, that soon they would be ploughing again.

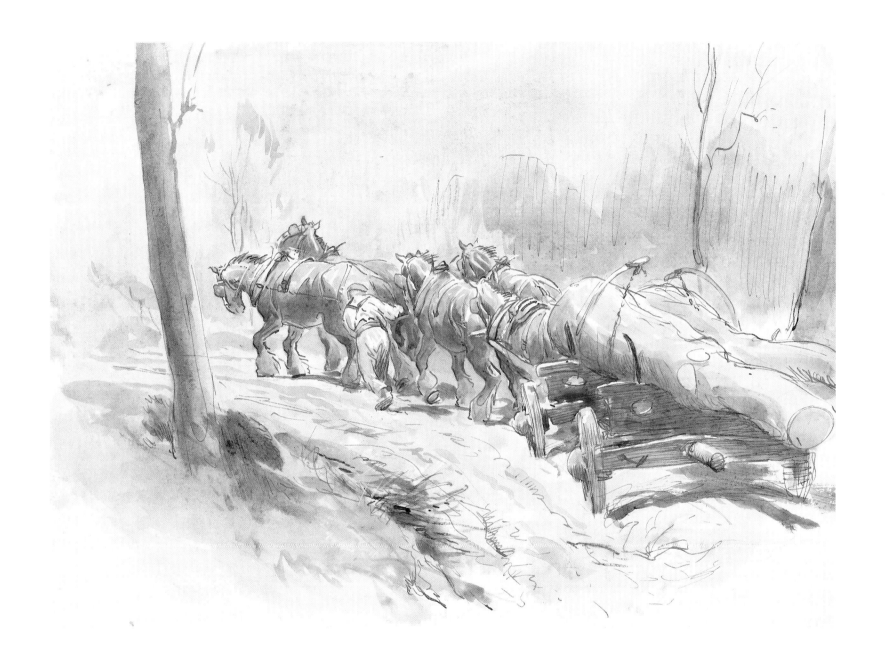

HARROW TO HARVEST · 127

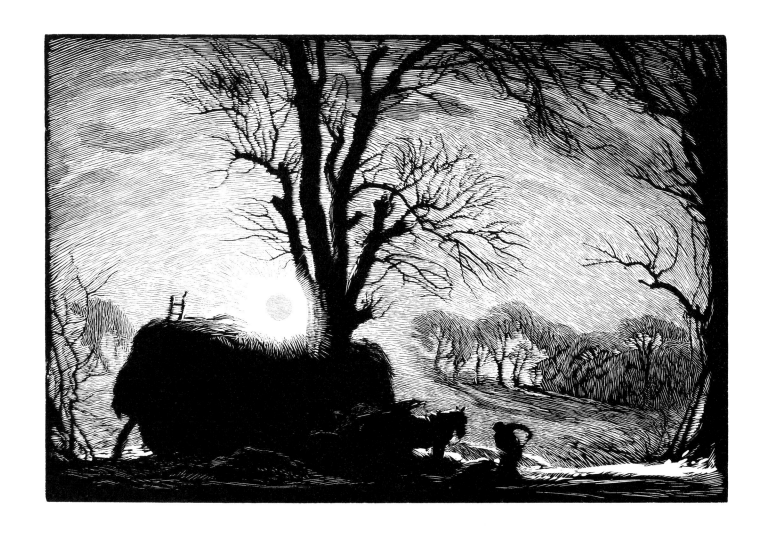

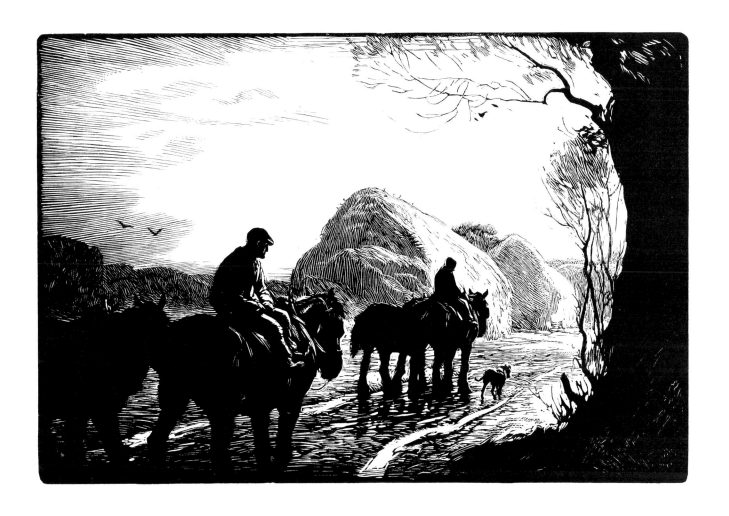

— 6 —

FAREWELL

IT IS POPULARLY believed that the demise of the working horse on the farm was due to the arrival of the tractor, and happened overnight. This is not entirely true. Rather like the slow advance of the working horse over the ox, the supremacy of the tractor was not achieved without a certain struggle.

Farmers, being a sceptical race, had little faith in the early tractors and for good reason. They had limited power, broke down often and were much slower in their work than the horse. They had little to commend them.

Even when technical advances made them more reliable, there was still the cost to consider. In the 1930s, a new Fordson tractor cost around £140, which was the same price as a pair of horses and harness, so why change? What is more, a good pair of horses had ten years' good steady work in them; no one knew how long a tractor was going to last.

The tractor started to make serious inroads into the kingdom of the working horse with the development of pneumatic tyres. It meant that tractors were less likely to get bogged down, which was a common problem; and the tedious business of changing from iron to rubber wheels when going on the road (as the law demanded) was dispensed with.

Inevitably, the tractor became more efficient. But even then, many farmers felt unable to bring themselves to get rid of the horse altogether,

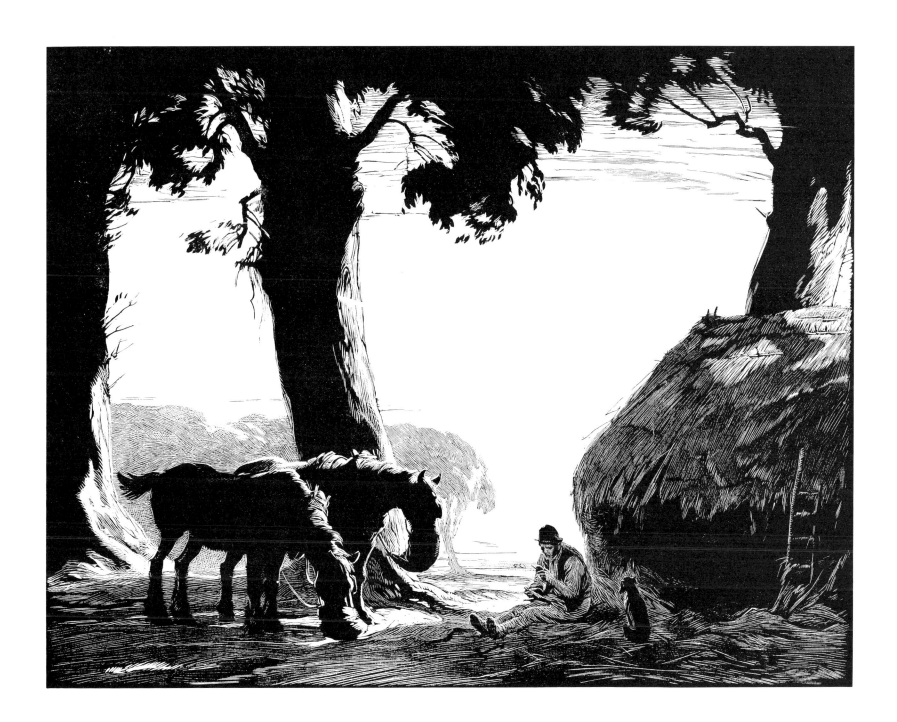

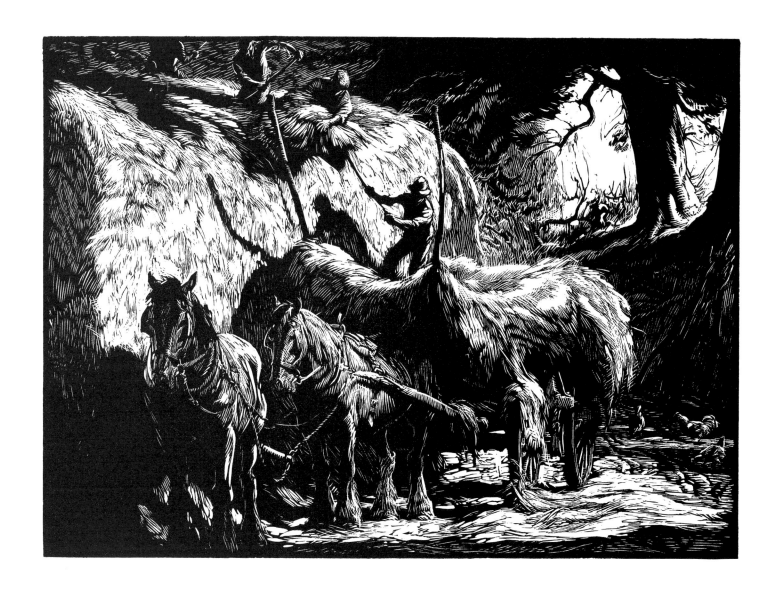

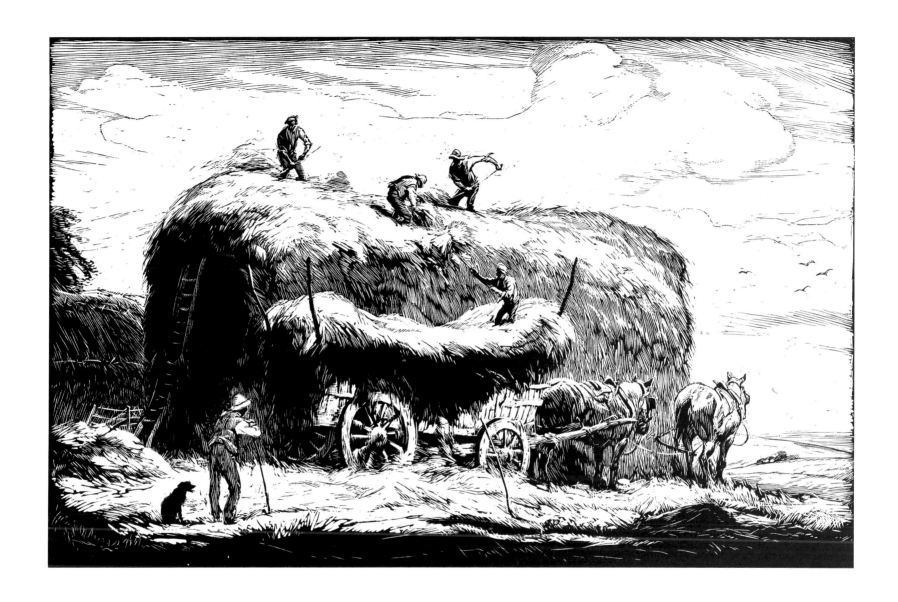

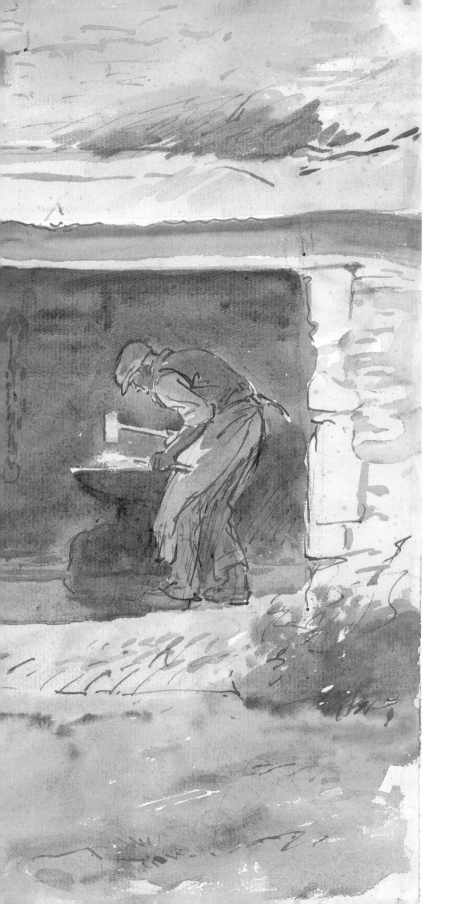

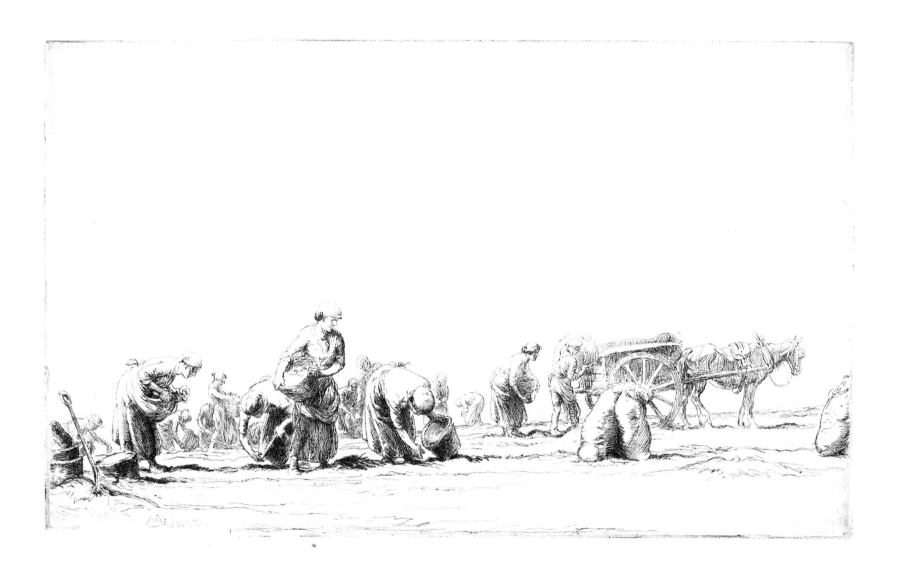

and so a familiar sight was a tractor ploughing and a pair of horses behind pulling harrows. As late as the end of the 1940s, there were few farms in England that did not have a horse at work.

George Soper saw the best of it. During the period he was painting and drawing, the horsemanship and the technology were at their most refined. The breeding of the horses had been put on a scientific basis, to bring forward the best horses for working the land; and the machinery the horse pulled had been slowly but systematically developed so as to raise the design of agricultural machinery to an art form. No wonder farmers were unwilling to give them up: they represented a high refinement of civilization. Horsemen were even less willing as this verse by an anonymous Norfolk horseman testifies:

> I ain't agin tractors. Not at all
> They do git over some ground
> No doubt we want more on 'em
> But I do miss my hosses.
>
> You can't call a tractor good company.
> Will that hear ye come inter the yard
> An let ye know tha's pleased to see ye?
> That ha' got lugs med o'steel
> But du they tahn backards to listen
> Ter ivery wahd you say to 'em?
> No fear they don't, not them.
>
> That earnt no good sayin "woosh"
> Nor yit "Cubbear" to a tractor.
> That hearnt got a nice sorft nose
> Like velvet
> What snubble up agin yer pocket
> Fer an apple or a bit o' sweet.

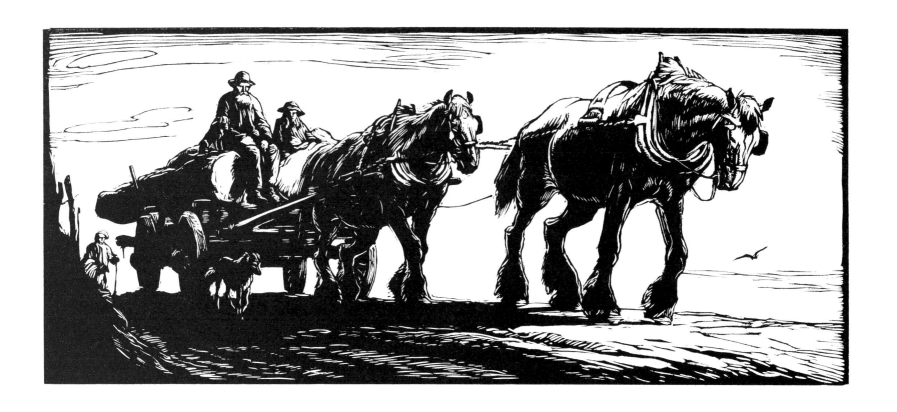

Why, a hoss is werry near a Christian,
That know Sunday from weekday.
Go you inter the yard a Sunday mornin'
You'll find 'em all layin down.
They know very well thass Sunday.

Do you remember them two brown 'uns?
Prince and Captain we named 'em
I was there when they were born.
Exactly a twelvemonth atwin 'em.
I browt 'em up, I brook 'em in
By the side o' thar old mother.

Ah, they wor a pair o' hosses,
The best round here for miles,
Lovely ringles all over thar coats,
Dapples our old man useter call 'em
Thar coats were like a bit o' silk.

You can't curry-comb a tractor
Nor yit you carn't coox it.
If you du that'll bahn yer hand
Or else freeze it.

Ah, tractors are all werry well.
They wholly git over some ground
No doubt we want more on 'em,
But still thass a masterpiece
How much I miss my hosses.

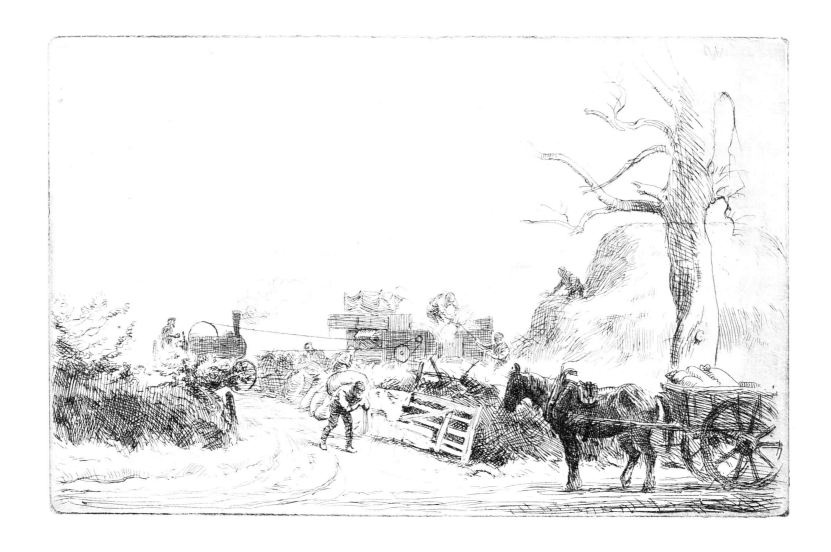

In an article that Eileen Soper wrote 20 years after her father's death, she says that work such as that done by George Soper could not be done today. Who will sit in a hedgerow and paint a passing tractor? Who can find inspiration in the man who slumps in the tractor, mesmerised by the uninspiring throb of his diesel engine? Farming with horses was in itself an art-form and with Soper it made a true and fertile marriage with a fellow artist. Eileen wrote:

> "Though much monetary reward and increased crops have been gained through mechanisation, most artists now look in vain for inspiration in the agricultural scene. The stacks and hayricks which were a beautiful feature of the landscape are now rarely seen; the stack built of machine-made bales is a hard, uncompromising shape. Ricks were the creation of craftsmen, as were the woven hedges and old five-barred gates – all in harmony with nature, and providing a setting indivisible from the artist's subject. . . . Perhaps the artist's loss is also the loss of the farm worker, who feels his sense of achievement lessened by the cold efficiency of mechanisation."

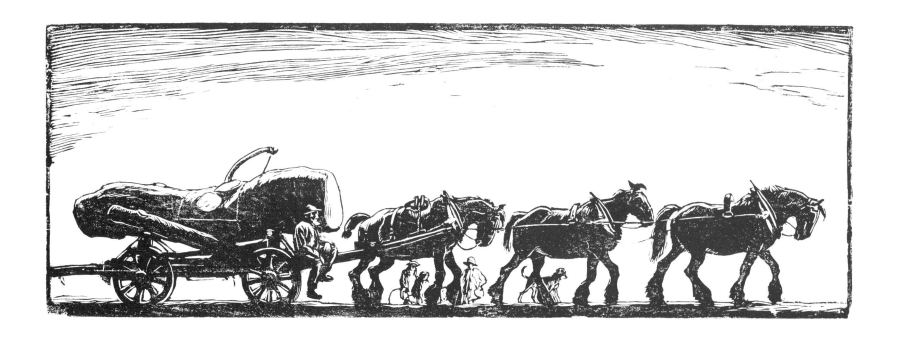

BIBLIOGRAPHY

The Horse in the Furrow, George Ewart Evans (Faber).

Ask the Fellows Who Cut the Hay, George Ewart Evans (Faber).

The Worm Forgives the Plough, John Stewart Collis (Penguin, London, George Braziller, Inc., New York).

The Book of the Farm, Henry Stephens (William Blackwood & Sons). Out of Print.

Farming, W. M. Tod (Dent). Out of Print.

Life on the Land, Fred Kitchen (Dent). Out of Print.

The Cornkister Days, David Kerr Cameron (Gollancz).

The Long Furrow, Ashley Cooper (East Anglian Magazine Publishing).

The Farmers of Old England, Eric Kerridge (Allen & Unwin).

A Song for Every Season, Bob Copper (Heinemann). Out of Print.

The Agricultural Notebook (1922), Primrose McConnell (Crosby Lock-wood). Out of Print.

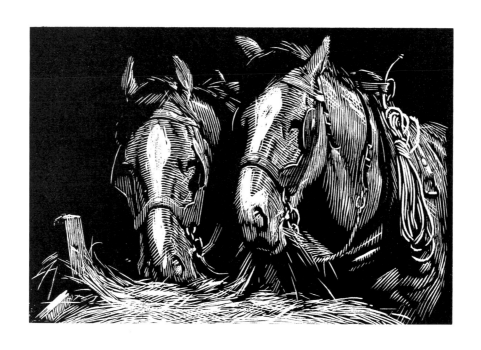